17 FEB 2005

THE ART OF DRAWING AND CREATING
MANGA
WOMEN

THE ART OF DRAWING AND CREATING
MANGA
WOMEN

PETER GRAY

ARCTURUS

Arcturus Publishing Limited
26/27 Bickels Yard
151–153 Bermondsey Street
London SE1 3HA

Published in association with
foulsham
W. Foulsham & Co. Ltd,
The Publishing House, Bennetts Close, Cippenham,
Slough, Berkshire SL1 5AP, England

ISBN 0-572-03020-7

British Library Cataloguing-in-Publication Data: a catalogue record for this
book is available from the British Library

Artwork by Peter Gray
Cover and book design by Steve Flight
Digital coloring by David Stevenson

Printed in China

CONTENTS

Introduction . 6

Materials . 8

The Head . 10

The Figure 32

Color . 56

Action .68

Projects . 86

NTROD

Manga are Japanese comic books, but the world of manga now covers a whole range of media and technology, since manga-style characters appear in animes (the Japanese word for animations), computer games, and graphic novels.

It's easy to feel daunted by the slick look of the artwork drawn by professional artists, but remember that every manga character you'll ever see was drawn by someone who was once a kid and had to learn.

Whatever styles of manga you like best and whether you prefer animation, comics, or games, they all start from the same point—DRAWING. All you need to get started is a brain, a keen eye, and some enthusiasm. Oh—and some paper, a couple of pencils and an eraser.

Later in the book, we'll look at using other materials to add color to your drawings. You might have some of these materials at home already. You might also have a

computer, to help you become adept at applying color to your drawings digitally. But never forget that all the fancy materials and equipment in the world can not make up for a lack of drawing skills—and those will only become honed and second-nature to you if you put aside the time to practice.

This book will help you to understand how manga action characters are constructed so that you can create original drawings of your own. Try to resist the temptation to dip into the book and just copy your favorite pictures. You'll need to come to grips with lots of principles if you want to be a good manga artist, and if you work through this book from the start, you'll be able to build up your skills gradually.

Most of all, keep in mind that drawing should be enjoyable. It may seem like hard work at times, but stick with it and you'll soon be rewarded for your efforts.

DAISY

Let me introduce you to Daisy. She'll be posing for some of the drawing lessons in this book. You'll also come across some of the other manga characters that inhabit her world.

You can see that Daisy is a confident girl. She's 17 years old, and she's a pretty good manga artist herself—she's been drawing comics since she was 12.

Daisy is also good at defending herself—something she learned from growing up on the rough side of town. But she avoids fights when she can—she'd much rather be drawing or hanging out with her friends. She's a good and loyal friend and knows how to have fun.

encils are graded from 1 through to 3. Number 3 pencils are harder and will make lighter lines. Soft pencils, like number 1, will make darker lines. Most ordinary pencils used in schools and at home are number 2. This is a good general-purpose pencil and perfectly good for manga drawing. However, if you can get ahold of a harder pencil, like a number 3, this will be useful for sketching guidelines—using this kind of pencil will make the guidelines less visible on your final drawing. You might then like to use a softer pencil, like a number 1, to darken the final lines of your drawings. The ideal would be a number 2 mechanical pencil. They are more expensive but produce a constant fine line. If you don't have a mechanical pencil, you'll need to sharpen your pencils regularly.

An eraser is almost as important as your pencils. It means that you can draw all the guidelines you want to help you shape your characters and then erase them later. You won't have to worry about making mistakes, either. There are dozens of different types of erasers available, but they all do the same basic job. Just make sure that yours doesn't leave behind any dirty marks.

Don't worry too much about the type of paper you use. Most of the drawings in this book were done on cheap photocopier paper. I often make rough designs on odd bits of scrap paper or on the backs of envelopes. You'll only need to worry about paper quality when you start to use more advanced materials.

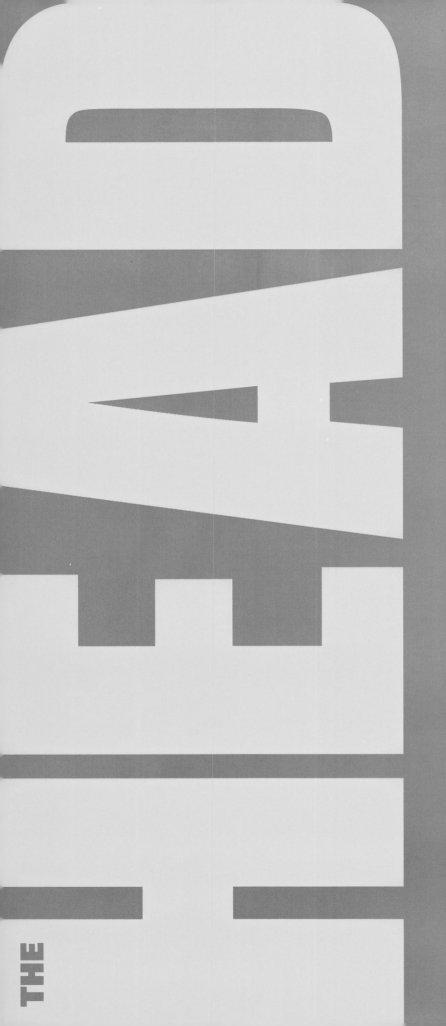

THE HEAD

Nearly everything about a person's character is shown through the features of their face. From this small part of the body, we make an instant decision about a person's age, sex, race, attitude, and mood.

Faces can be fat or thin, long or round, square or heart-shaped, cheerful or sinister, pretty or plain. Although no two faces in the whole world are exactly the same, in manga-style drawings female faces tend to look quite similar. They are usually pretty, even if they are tinged with evil, and they often have the same kinds of features: large eyes, small nose and mouth, and a pointed chin.

We'll start each drawing in this section by sketching some guidelines that form a framework for the head. We'll then add more guidelines for other features, step by step. You'll want to erase most of these lines at some point, so don't make them too heavy. Use your hard pencil to draw them or, if you only have a soft one, press lightly so the lines are fainter.

I've made my guidelines quite dark in this book, but that's only so you can see them clearly to copy them. I've also highlighted the new lines you need to draw in each step by making them red.

THE HEAD
THE HEAD
THE HEAD
THE HEAD
THE HEAD
THE HEAD
THE HEAD
THE HEAD
THE HEAD
THE HEAD
THE HEAD
THE HEAD
THE HEAD
THE HEAD
THE HEAD
THE HEAD

Front View

Study each picture carefully to see what features you need to add.

Step 1

First draw a framework for Daisy's head. Start with a vertical line—this will help you make your picture symmetrical. Draw an upside-down egg shape over this, then draw four horizontal lines across it—the longest one sits halfway down the head and the others are evenly spaced around it. Add a short pencil stroke for Daisy's mouth.

Step 2

Eyes sit about halfway down the face. First draw two arches for Daisy's irises—use your framework to help you place them. Like most manga eyes, they are more than a whole eye's distance apart. The ears start level with the top of the eyes and finish level with where the nose will be. Add some guidelines for the hair and neck.

Step 3

Give the eyes and ears some more detail, then add a small upturned nose. Shape the chin to give it a gentle angular look.

Step 4

Sketch in the rough shapes of the hair and the direction in which it flows. Here Daisy's hair is tied back.

Step 5

Give the hair and face more detail. Add a small circle to each eye to make a bright highlight.

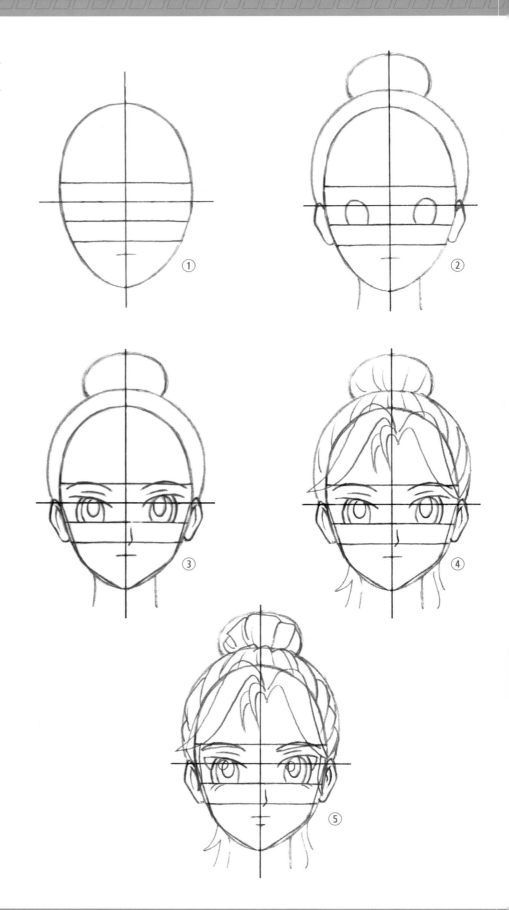

Step 6

Now go over your pencil lines with a black ballpoint or felt-tip pen. Use smooth, confident strokes. Shade in her pupils as well as the top half of each iris since this part is in the shadow of the eyelid. Leave the bright highlights white. Add the eyelashes, too. Once the ink is dry, rub out any remaining pencil marks, including the ones that made up your original framework.

Don't be overawed by the colored pictures at the end of drawing exercises like this one. We'll look at coloring later in the book. If you do want to add color, you might like to copy this color scheme.

The precise position and size of a person's eyes on the face change with age. There's more about this on page 19. You'll find more tips on drawing eyes on pages 22-23.

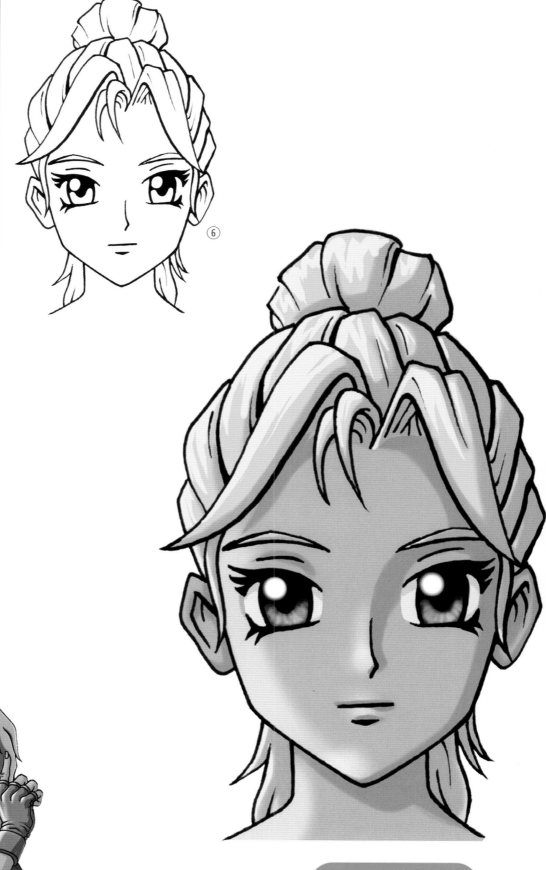

⑥

Profile

Daisy's head looks more circular when it is drawn from the side.

Step 1

To make a framework, draw a circle, then attach a pointed shape to the bottom left of this to form the face and jaw. Draw a horizontal line across the center of the whole shape, then add three more horizontal lines as you did in the previous drawing. Make a short pencil stroke for the mouth.

Step 2

Use the guidelines to help you place Daisy's eye and ear. From this angle, the iris takes the shape of a narrow arch and sits close to the front of the face. The ear is just over halfway back on the side of the head. To draw the outline for the hair, it may help you to extend your main horizontal guideline. Notice how the neck slopes backward.

Step 3

Shape the front of Daisy's face, then soften the line forming the underpart of her chin. Now add some detail to the eye and ear.

Step 4

Study the picture to make sure your guidelines for the hair show the different directions in which it flows.

Step 5

Work on the hair to make it more angular—like the bright highlights on each eye, this is a key feature that distinguishes manga artwork.

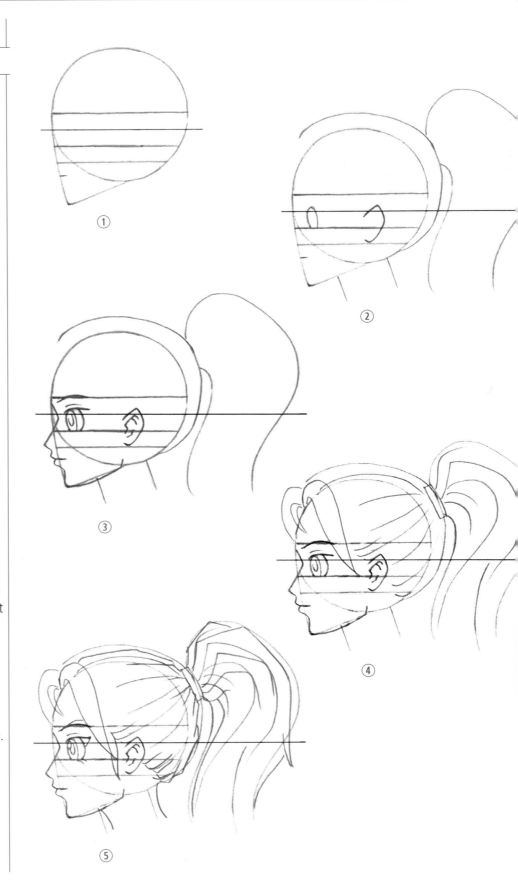

Step 6

When you're ready, go over your pencil lines in pen, as you did for the previous drawing. Let the ink dry, then erase all remaining pencil lines to leave a clean picture.

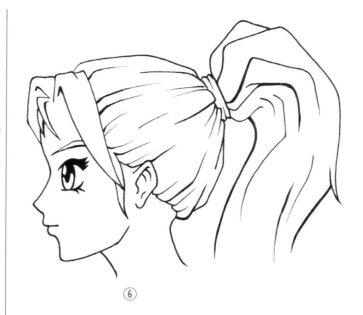

⑥

Outlining your drawing using black felt-tip pens of different thickness will allow you to make some lines heavier than others, adding solidity to your picture.

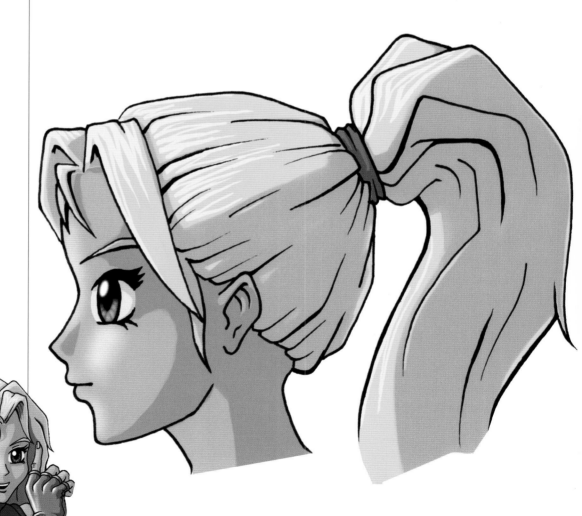

¾ View

Daisy has turned her head so that we can see the front and the side.

Step 1

Draw a shape that's like a pointed egg standing upside down and tilting to the right slightly. Notice how the vertical guideline curves. Add four horizontal guidelines as before and a tiny one for the mouth.

Step 2

The eye on the left of the picture is slightly angled away from us, so make the arch of the iris narrower and place it closer to the vertical guideline than the other eye. Place the ear, hair, and neck.

Step 3

Add some detail to the eyes and ear. To draw the nose, start above the eyebrows and draw a long curve ending in a little point. Reshape the jawline to make it more angular.

Step 4

Draw the guidelines for Daisy's hair. Notice how one piece falls across the eyebrow. Don't worry that your pencil lines overlap each other, you'll erase unwanted lines later.

Step 5

Give the hair more shape, then work on the facial features again. When you mark the bright highlights on Daisy's eyes, make the one on the left oval-shaped rather than round.

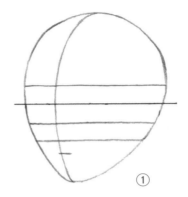

①

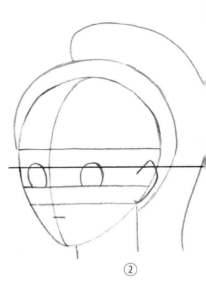

②

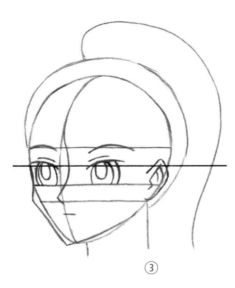

③

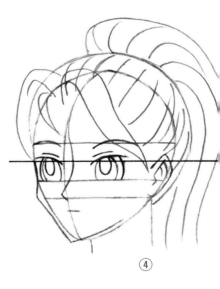

④

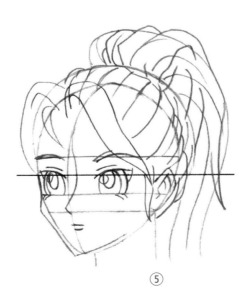

⑤

Step 6

Take another look at your picture—
if the face looks odd, go back over
all the steps so you can try to work
out where you went wrong. Start
again if you have to—it'll be worth
it in the end. Once you're happy with
your sketch, go over the lines that
you want to form your final picture
using a black felt-tip or ballpoint
pen. Notice how I've changed the
shape of Daisy's neck at this point
by curving it to make it look softer.
I've also used a smoother line to
draw the side of the face to make
the cheekbone less prominent.
When the ink is dry, erase your
pencil marks.

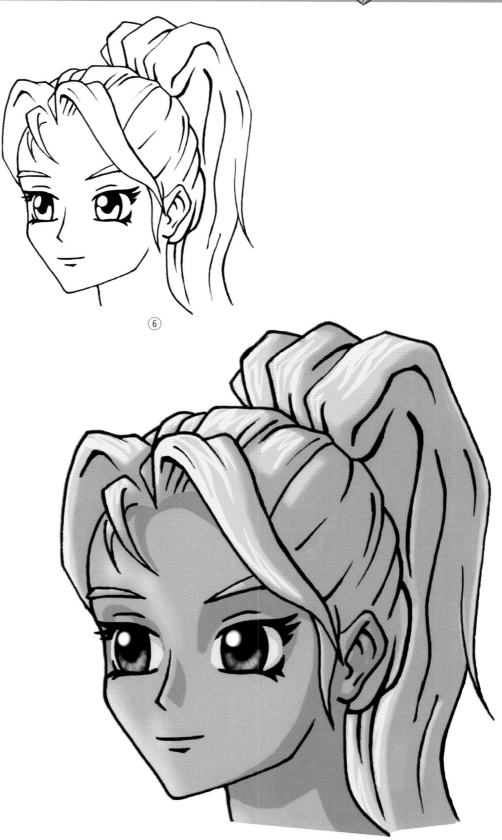

⑥

Different Angles

Faces are rarely drawn from the front or side—like real people, manga characters move their heads in all directions. Some angles are trickier than others, but remembering to use guidelines will always help you.

① When Daisy turns away like this, her facial features almost disappear from view. Her hair becomes very prominent, as does the ear. Notice how the guidelines curve.

② When Daisy looks down, the horizontal guidelines curve up at the ends to make her ears sit higher up on the head. All the facial features sit toward the bottom of the egg shape.

③ If Daisy tilts her head down at an angle, we see more of the side of her head again.

④ When Daisy tilts her head upward, the horizontal guidelines should curve

downward at the ends to make the ears sit lower down on the head. Notice that we can see less of Daisy's hair from this angle.

⑤ If you look down on Daisy, the top of the head is circular. The face is hidden except for the eyebrows, the eyelashes, and the tip of the nose.

⑥ From the back, all you can see of the head is the hair, neck and ears.

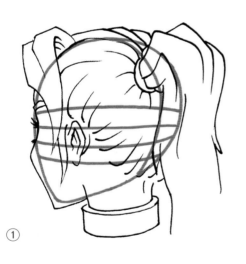
①

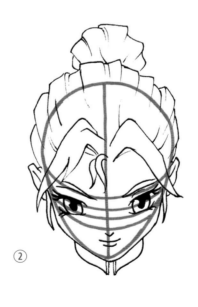
②

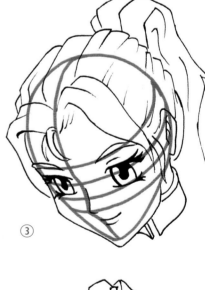
③

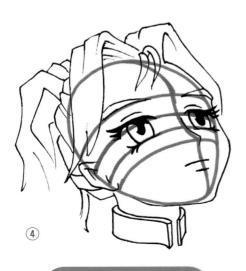
④

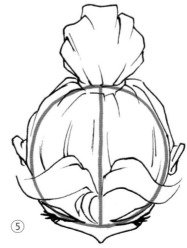
⑤

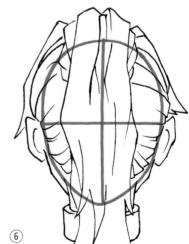
⑥

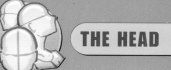

Proportions

These pictures show Daisy at different ages. They demonstrate how the relative proportions of your facial features change as you get older. Try drawing all four pictures. Notice that the nose and mouth stay very similar at all ages.

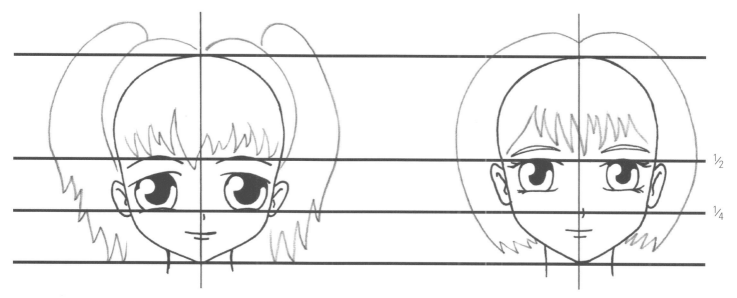

A toddler's eyes are very large and sit low down on the head.

During childhood, the head grows to be larger in relation to the eyes, so the eyes look smaller and sit higher up on the head.

This is Daisy now—she is 17 and still has some growing to do. Her eyes appear even smaller and start to cross the halfway line of her head.

When Daisy is fully grown, her pupils will sit exactly halfway up.

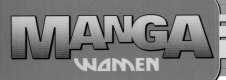

Expressions

The human face is capable of expressing a broad range of emotions. Good comic artists apply this to great effect, using their characters' moods and reactions to help with telling the story.

Here Daisy is showing some of the expressions that are common in manga comic books.

Simple changes >>

You should be able to tell what each of these faces is expressing right away, even though each picture is made up of only a few simple lines and circles. Now practice drawing them. Note how very simple changes—the tilt of an eyebrow or the drop of a lip—can bring about a complete change of mood.

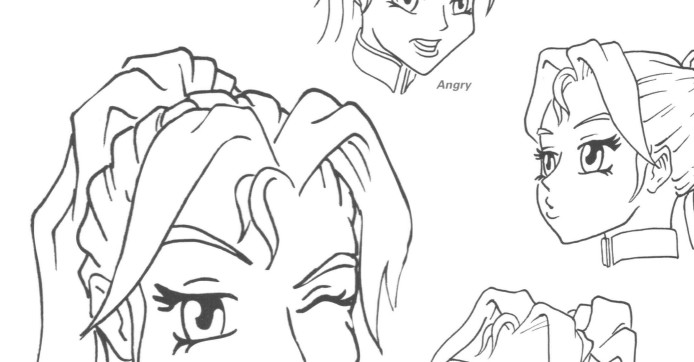

Angry

Relieved

Playful

Alarmed

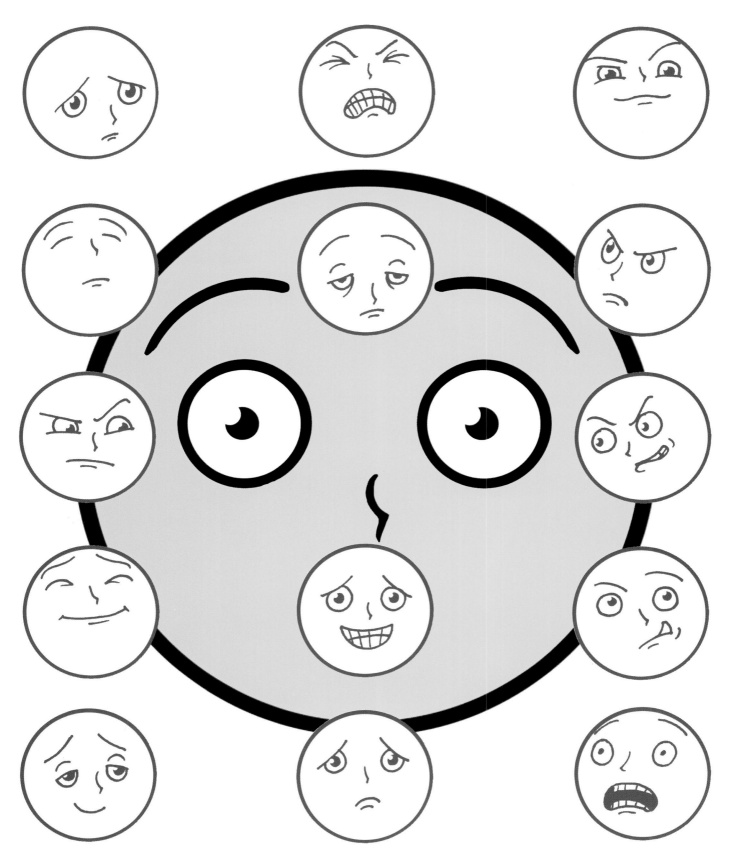

Eyes

One of the most distinctive features of manga females is large, shiny eyes. When you draw them, bear in mind that the eyeball is round even if it doesn't look it because some parts are hidden by the eyelids.

① Daisy's eyes

Her iris (the colored part) and pupil (the black part in the middle) are both oval-shaped. A circle in the top left of each eye overlaps the iris and pupil to form a bright highlight, making the eye look shiny.

② Adding color

The top part of the iris is black—this is because the upper eyelid is casting a shadow over it. The area of the bright highlight is left white.

③ Turning away

In this position, we can see less of the iris and pupil and more of the white of the eye. The whole eye also appears narrower. First, sketch a circle-shaped eyeball, and within it draw a curve slightly in from the left—think of this curve as where the skin covers the eyeball. See how this changes the shape of the eyelid and eyebrow? The iris and pupil become narrower and the bright highlight is now also oval-shaped.

④ Turning farther away

Again, start with a circle but draw your curve farther to the right to make the new shape of the eyeball even narrower. Place the oval shapes for the iris, pupil, and highlight farther to the right and make them narrower too.

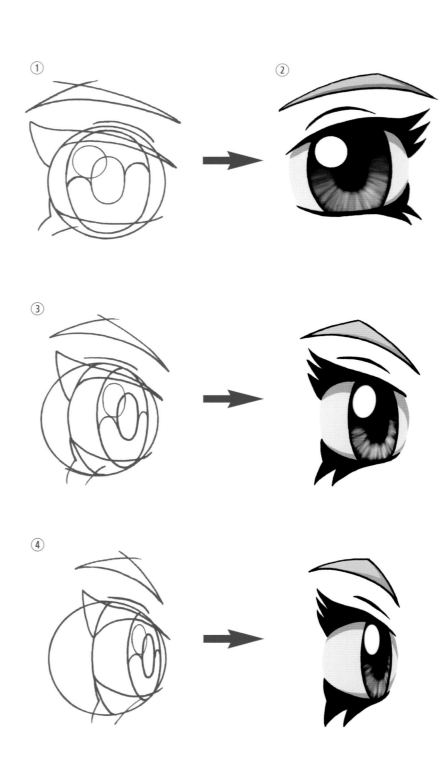

Expressive eyes

Eyes can say a lot about a person. Here are some more pictures of Daisy's eye to show you how it can be drawn differently to illustrate what she is doing or how she is feeling.

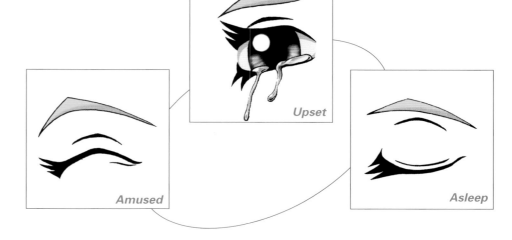

Good Girl's eyes

These eyes all have large irises and large pupils, telling us that they all belong to fairly good characters. Their shape, color, shine patterns, and eyebrows are all different, however, so each one has a distinctive look.

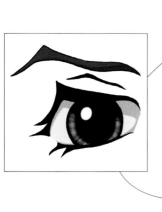
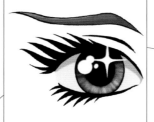
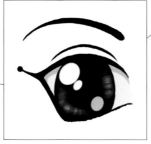
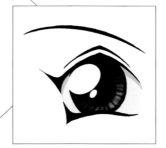

Bad Girl's eyes

Changing the shape and details of the eyes is the most effective way of turning a good character into a bad one in manga. If you draw narrow eyes with small pupils, the character will immediately look evil. Try it!

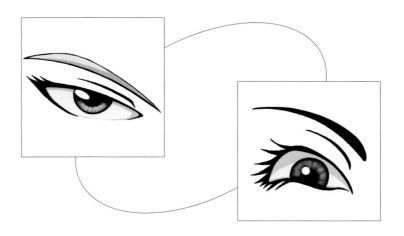

Good Girl Hale

Females of different ages have different characteristics, but the techniques you use to draw them are the same.

Step 1

Hale is much younger than Daisy. Her head is rounder, so start by drawing a circle instead of an egg shape. We'll draw her looking down and to the right, so your vertical guideline should curve out to the right. Place three horizontal guidelines as shown—they curve upward at the ends.

Step 2

Place the large irises of Hale's eyes as shown. Remember that from this angle, one will appear thinner than the other and it will sit nearer to the vertical line. Draw a small ear and two long thin eyebrows.

Step 3

Add some detail to the eyes and ear, then draw on the nose and mouth.

Step 4

Make the bottom of the hair more jagged and draw some longer pieces of hair around the sides of the face—don't cover up the ear. Place a large bow on top of the head.

Step 5

Add bangs, then work on the eyes. Each eye has three bright highlights—two are circle-shaped and sit in the top left of the eye. The third looks like a little fang and sits in the bottom right.

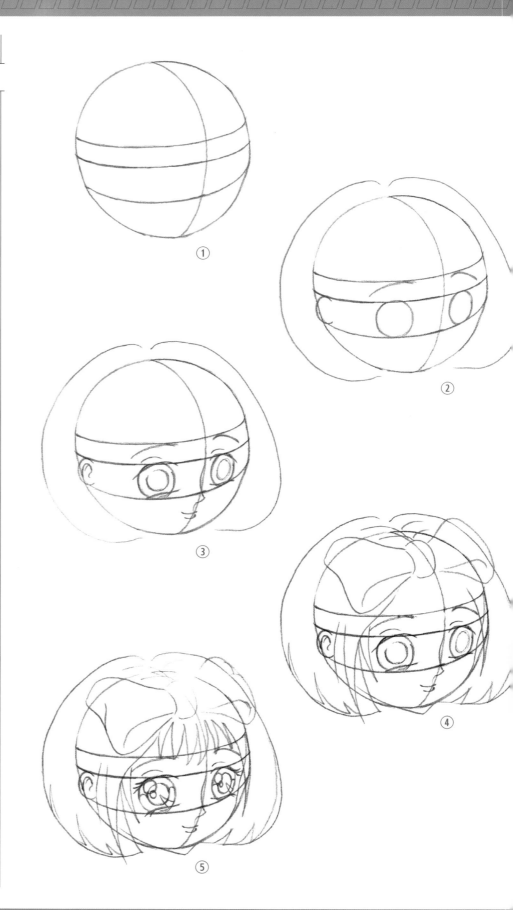

Step 6

Go over the light pencil lines that will form your final drawing with heavy pencil lines, erasing the lighter lines as you go. Add some lines to show the gathers on the bow. Shade in Hale's pupils as well as the top part of each iris, but make sure you leave all the bright highlights white. Now ink over your picture. Leave it to dry, then erase the rest of your pencil lines.

Add the color, or wait until you've worked through the Color section of this book and come back to your drawing later.

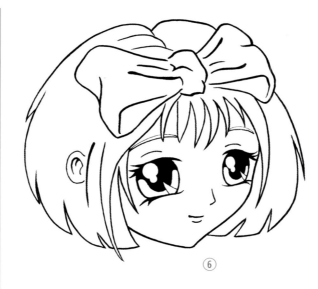

⑥

Young characters like Hale have plenty of space for more than one bright highlight in each of their huge eyes! The highlights can form a whole range of patterns.

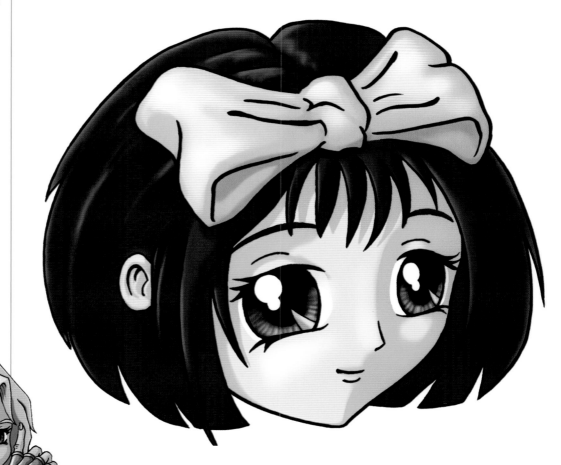

Good Girls

One of the best aspects of drawing is inventing characters. Here are some that I've made up. You can tell they are all good characters because they have large pupils (even when they have small irises) and friendly expressions. Each girl has different strengths, weaknesses, interests, and attitudes—and it all shows in her face. Try drawing them or invent some characters of your own.

Love-lorn

City Chick

Daydreamer

Romantic

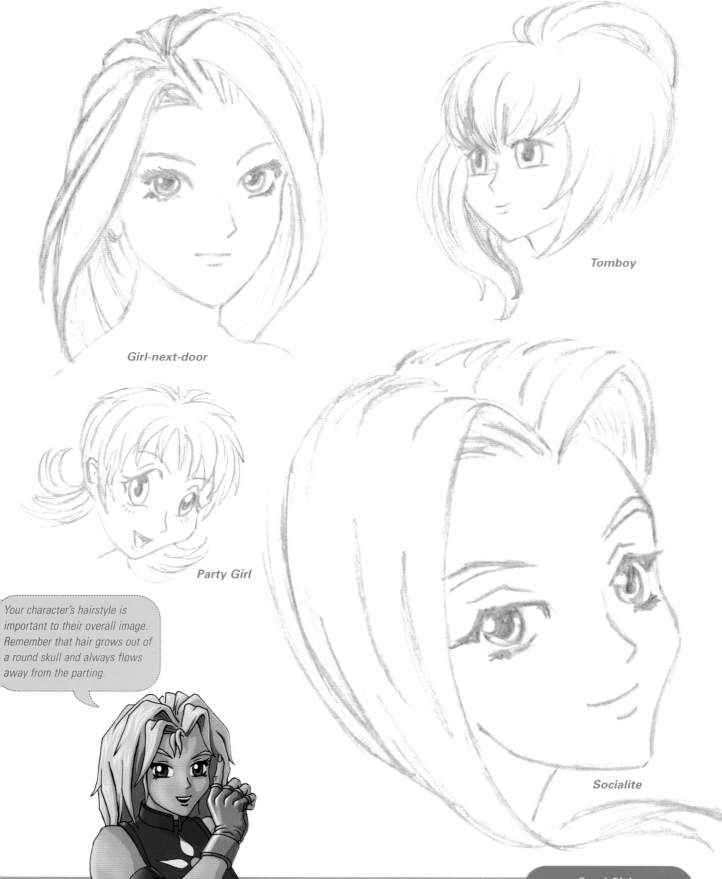

Girl-next-door

Tomboy

Party Girl

Your character's hairstyle is important to their overall image. Remember that hair grows out of a round skull and always flows away from the parting.

Socialite

Bad Girl Ruelle

This character is a grown-up woman—and an evil one at that. We'll be drawing a ¾ view of her.

Step 1

Start with a long egg shape that is pointed at the bottom and tilts to the right. Add a vertical line that curves out to the left. Carefully copy the positions of the two horizontal lines—both curve up at the ends since Ruelle's head is tilted down slightly.

Step 2

Draw Ruelle's eyes across the top horizontal line so they sit high up on her head. Add a large curved ear. Place the mouth, neck, and hair.

Step 3

Add some more detail to the facial features. Notice how low down the top eyelids are, making the eyes look heavy. The eyebrows are sharply angled and the nose long and narrow. Draw the mouth open.

Step 4

Re-shape the face to make the cheekbone jut out more. The jaw shape is long and narrow. Add some lines to define the lank hair.

Step 5

Add a strip of hair falling across Ruelle's face and re-shape the ends to make them more straggly. Give her long eyelashes, but make her pupils small. Thicken the eyebrows and shape the lips.

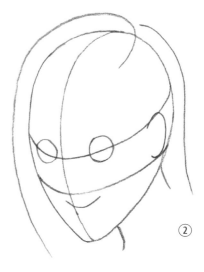

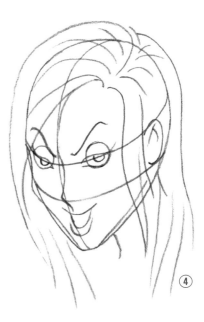

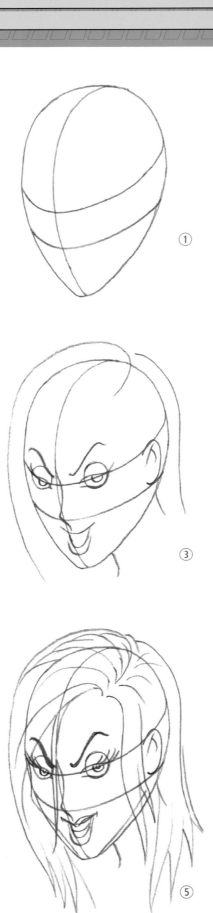

Step 6

Now go over your picture again, using heavy pencil lines to bring it to life. Shade inside Ruelle's mouth and add a couple of frown lines above her nose. Go over your final lines with a black ballpoint or felt-tip pen, and when the ink is dry, erase the rest of your pencil marks.

By using blues and grays, I've made Ruelle's coloring as cold as her character. Try using the same kinds of shades.

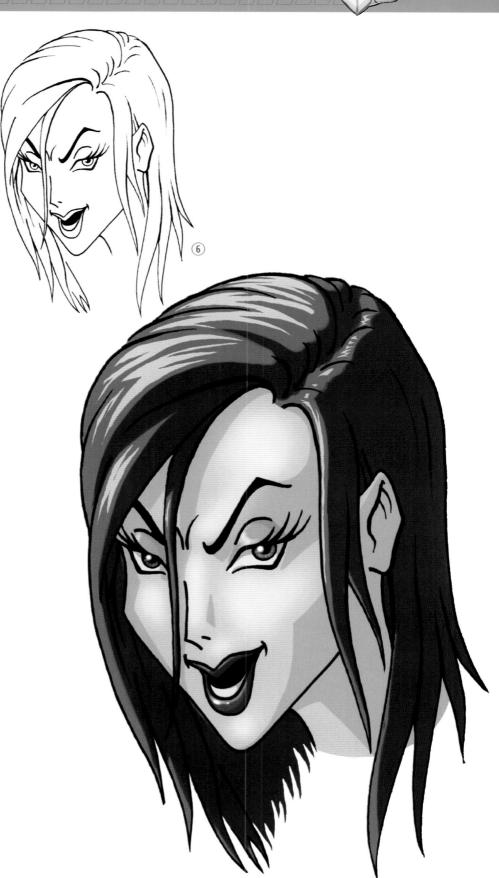

Bad Girls

These girls are not very cute. Their faces are mostly defined by the shape of their eyes and eyebrows, but the hair and mouth shape also add to the harsh look. Try drawing them all. Invent some others, too.

① Erica screws up her face so the eyes squint and the nose wrinkles—add frown and sneer lines to emphasize this.

② Jarla's irises and pupils sit high up in her large eyeballs to make her glare.

③ Breeta's blunt bangs, tiny pupils, and small pouting mouth make her look cold.

④ Notice the angle of Sadi's neck and how her top eyelids sit high above the irises, making her appear stand-offish.

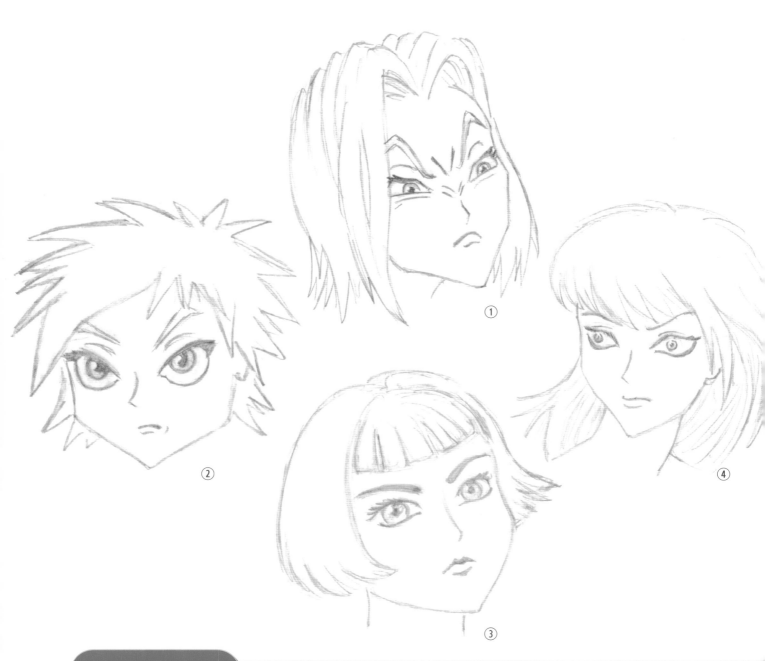

Nasty Daisy

This is Daisy's evil twin, Detta. Notice how just a few small alterations to Daisy can change her from a friendly and helpful teenager into a cold and scheming bad girl!

Drawing hints

Give Detta's eyes less height and make the pupils smaller. Angle the eyebrows down toward the center, and curl the lip at one end to make Detta scowl. Give her lots of earrings and put a ring through one eyebrow. If you decide to color in your picture, add some darker patches to her face to cast shadows across it. Make the color of her eyes more gray than Daisy's. Use a dirtier yellow for the hair.

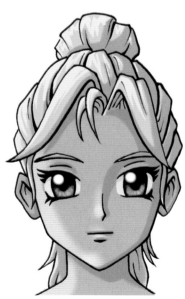

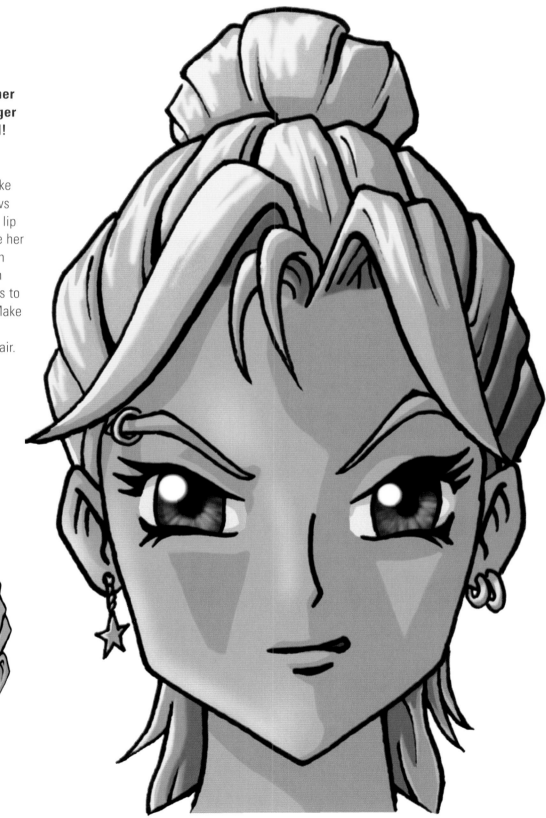

THE FIGURE

As we've seen, a face can express a great deal about a character. But there is, of course, much more to creating a character than a face. Each face needs a body so the character can leap into action.

Our body is a very complex machine, with bones, muscles, fat, and skin all working together. You could study its intricate details forever and still not know everything about it. But to start drawing a manga-style body, you just need to learn a few basics about the structures that lie beneath the skin. You'll find that your drawings of the outside appearance of the body will be easier to construct if you understand what goes on inside.

Doing some research will help too—look at yourself in the mirror and try moving your body into different poses so you can study how it looks.

Don't expect your drawings of bodies to turn out perfectly right away. Making mistakes is all part of the learning process and will add to your experience as an artist.

THE FIGURE
THE FIGURE
THE FIGURE
THE FIGURE
THE FIGURE
THE FIGURE
THE FIGURE
THE FIGURE
THE FIGURE
THE FIGURE
THE FIGURE
THE FIGURE
THE FIGURE
THE FIGURE
THE FIGURE
THE FIGURE
THE FIGURE
THE FIGURE

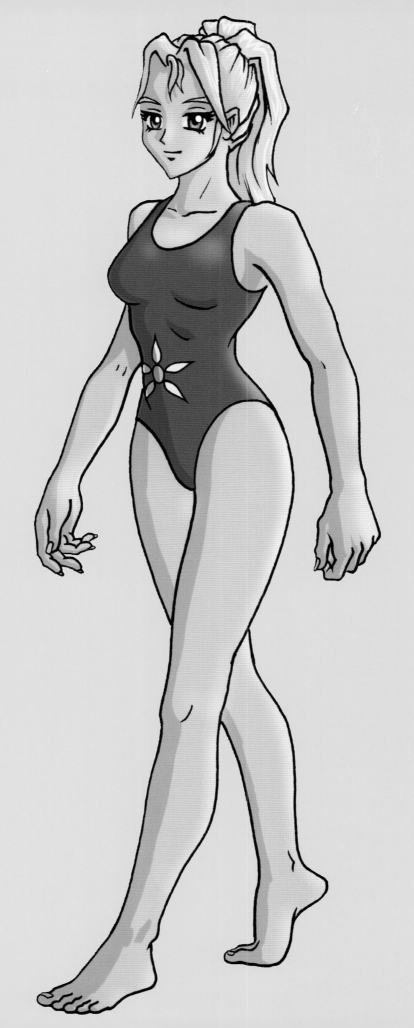

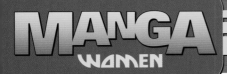

The Skeleton

Think of the skeleton as a frame upon which you can hang muscles, skin, and clothing. Although it's quite complicated, you don't need to know about all the bones—you just need to think about the basic structure. The body is able to bend because of the joints. The arms have shoulder, elbow, and wrist joints, while the legs have hips, knees, and ankles.

① **Front view**

This is a simplified version of Daisy's skeleton. The head, chest, and hips can all be drawn as simple oval shapes, separated by short vertical lines for the parts of the spine at the neck and lower back. Notice that the arms do not hang directly from the chest but are separated by shoulder bones, while the legs are joined onto the hips. The joints are all drawn as small dots.

② **Side view**

Earlier in this book we saw how when Daisy turns her head to the side, some of the features get thinner or disappear from view. The same is true for the whole body. Notice how from this angle, you can see that her back is slightly arched. The arms are slightly bent and the leg bones curve.

③ **¾ view**

Here, the three vertical guidelines (one each on the head, chest and hips) have moved off-center and curve out to the right.

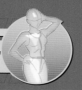

Muscles

Here's Daisy's skeleton again with an outline drawn around it to show how the flesh and muscles wrap around the bones. Like most manga women, Daisy has a muscular, athletic look. Her outline mostly follows the shape of the skeleton, except that in some places, like where there are powerful muscles over the shoulder joints and on the thighs, the outline curves out more. The outline tapers in at the joints. Some parts of the body have no muscle, so you can notice the bones under the skin. These parts are highlighted with red dots.

① **Side view**
Notice how the outline curves at the top of the leg at the front for the thigh muscle. Lower down, it curves in the opposite direction for the calf muscle.

② **¾ view**
The lines showing the curves of the muscles on one leg will follow the shape of the lines on the other leg. One leg also overlaps the other.

③ **Thinner characters**
To make your character thinner, draw the body outline closer to the skeleton structure and make your pencil line more angular, to reduce the bulges.

④ **Larger characters**
To give your character a larger build, make the outline curve more. The skeleton remains the same for these different body types.

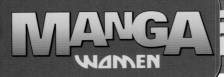

Front View

Daisy has volunteered to stand very still while we draw her body.

Step 1

Start with a vertical line to help you make your picture symmetrical. Draw Daisy's egg-shaped head at the top. The chest shape is like a large oval with a chunk taken out to show the shape of the rib cage. An oval lying on its side makes the hips. Space out the three shapes to leave space for the neck and stomach.

Add the limbs (arms and legs). Start by drawing the two collarbones coming out of the chest. Study the picture to see how long the limbs should be—marking the joints will help you get the proportions right. The legs are much longer than the arms. Notice how the wrist joint of the hand on the left of your picture is level with the joints at the tops of the legs.

Step 2

Draw some curves around the major bones to mark where the flesh and muscles will go—don't worry about going around the joints yet. Remember that the tops of the legs (the thighs) will be broader than the sections below the knees (the calves). The upper arms should be slightly broader than the forearms. Draw in the neck and shoulders too.

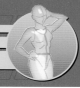

Step 3

Fill in the missing parts of your outline and see the body take shape before your eyes. Curve out your lines to make the shoulders look strong. The outline curves in at the elbows and wrists, but there should be a little kink on the outside of each wrist to show the bone. Draw some curves for the chest as shown and add the lines of the waist. Now for the legs—from this viewpoint, the knee and ankle joints bulge out at the sides slightly.

Take a stab at giving the hands some shape—notice that the thumbs have a muscly part, so make the outline more curved here. Add the feet, but don't worry too much about them since we'll look at hands and feet in more detail later. Finally, start outlining the features on the head, applying the techniques we looked at in the previous section.

Step 4

Mark the lines of Daisy's swimsuit and give her fingers and toes more definition. Now add a few details to the face and hair—look back at page 12 of the Head section of this book if you need some more help with this.

>>

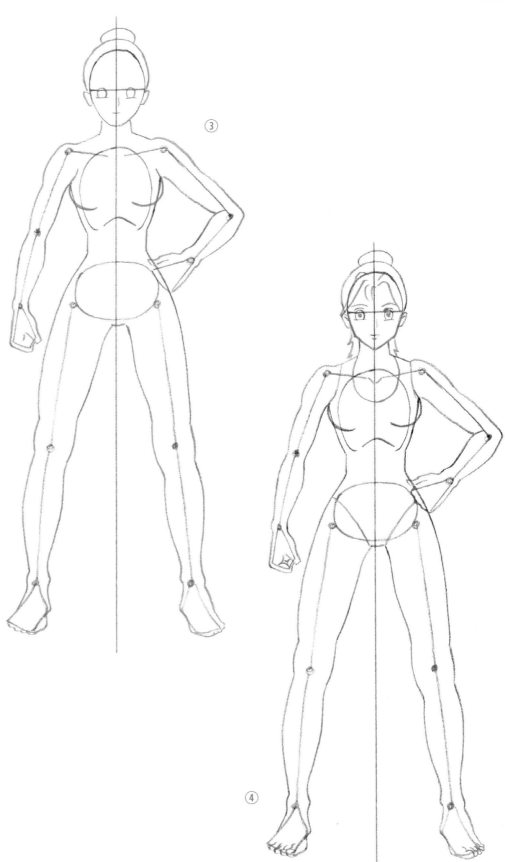

<<
Step 5
Go over your final pencil lines with a black felt-tip pen or ballpoint pen. Now draw some little lines to define Daisy's neck muscles, collarbones, and rib cage. Add some detail to the knee joints, then work on Daisy's face and hair.

Step 6
When the ink is dry, erase all the guidelines you drew for Daisy''s skeleton. That's your first manga body finished!

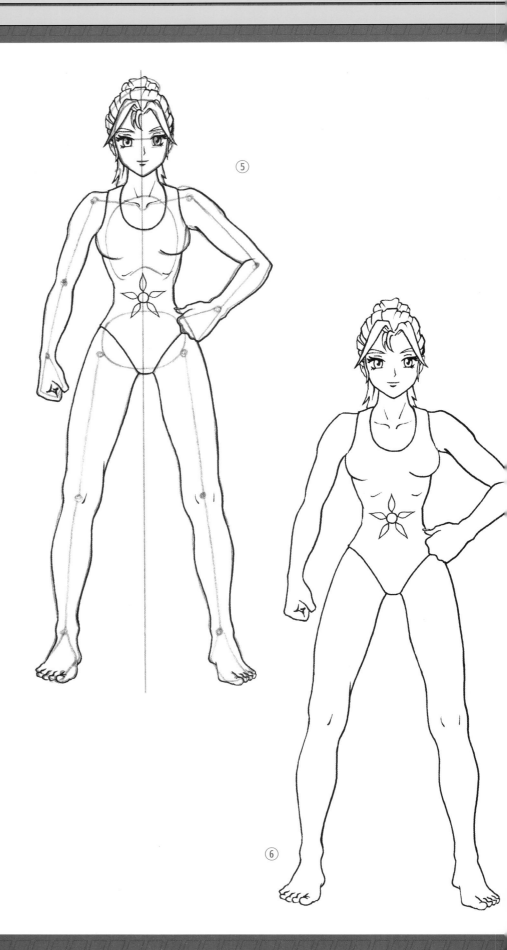

Step 7

Color in Daisy if you want to—or wait until you've worked through the Color section of this book.

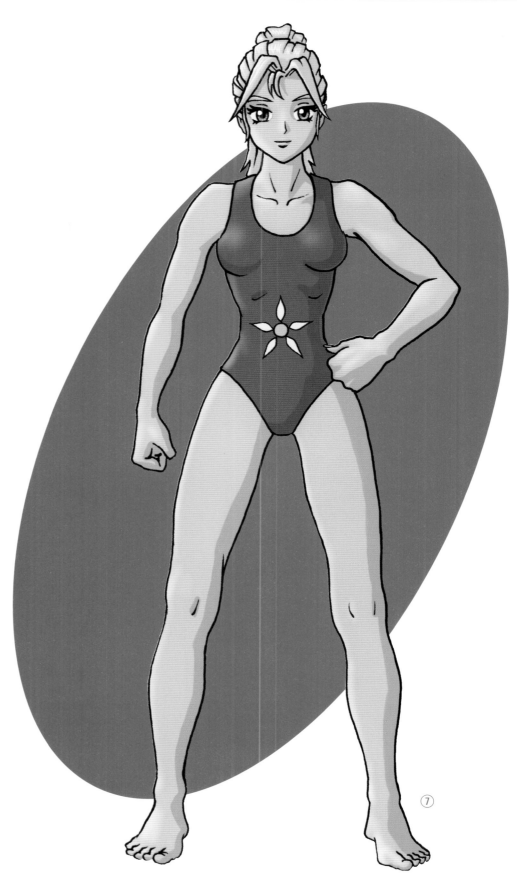

⑦

Profile

Daisy has turned to the side and changed her pose slightly—you can see one arm but both legs.

Step 1

Draw the basic shapes of the head, chest, and hips, carefully copying where they sit in relation to one another. The head is quite circular from this angle and sits slightly ahead of the chest and hips. The oval of the chest tilts backward at the top. From this angle, the hips form a circle shape. Add the neck and lower part of the spine. Notice how both parts curve, particularly the lower part—this arch of the back is very important to the style of manga artwork. Add the limbs— start by marking the joint at the top of the arm to help you position the collarbones and arm bones correctly. When you draw the legs, notice how the calf bones curve to give the legs a more glamorous profile. Just draw rough outlines of the hand and feet for now.

Step 2

Draw some rough lines around the main bones of the body for the flesh and muscle. It's very important that you get these right before you complete your outline.

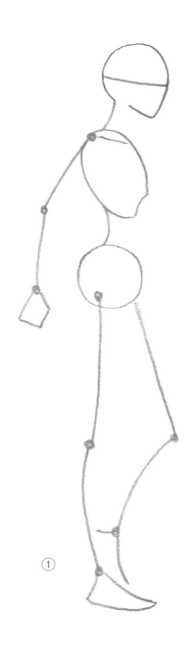

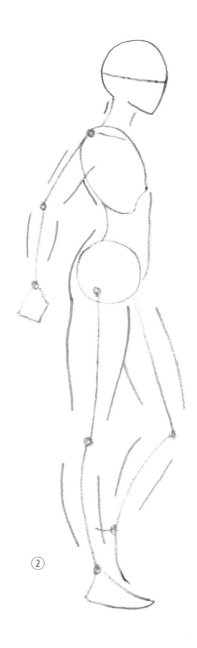

Step 3

Fill in the gaps of your outline. Study the picture to see how it curves in and out around the joints. Add the hand and the feet. When you outline the hair, notice how the ponytail falls down at the back so you can see the bottom of it between Daisy's arm and the arch of her back. Now place her facial features.

Step 4

Draw in the lines of Daisy's swimsuit at the top and bottom. Now add more detail to Daisy's hair. Remember to think about what way it is flowing. Add more detail to the eye. Now mark her toes and draw a little line around the outside of her ankle to give it definition. Small details like this make your final picture much more lifelike.
>>

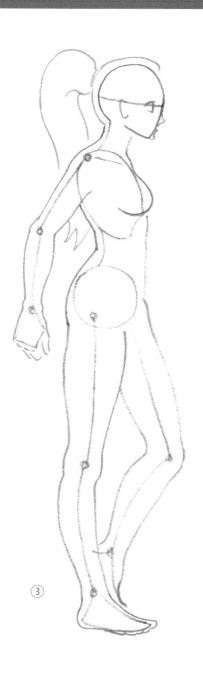

③

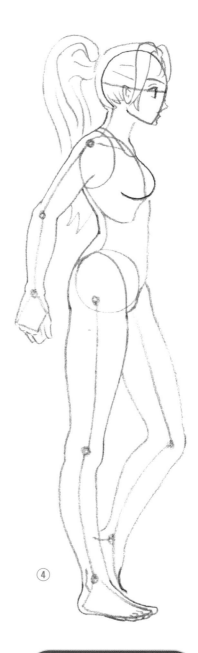

④

<<
Step 5

Draw over the main lines of your picture in heavy pencil, adding more detail to the hair, face, hands, and feet as you go along. Don't forget the flower on Daisy's swimsuit— you'll only be able to see half of it from this angle. Go over your heavy pencil lines with a black ballpoint or felt-tip pen.

Step 6

Once the ink is dry, erase all the pencil lines of your skeleton framework.

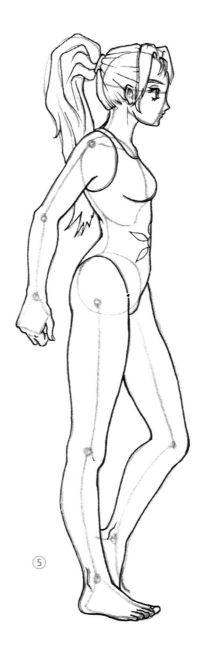

⑤

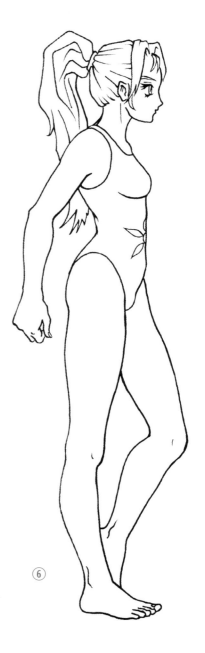

⑥

Step 7

Now you can color in your picture if you want to—try experimenting with different color schemes to change Daisy's hair color, skin tone, and swimsuit design.

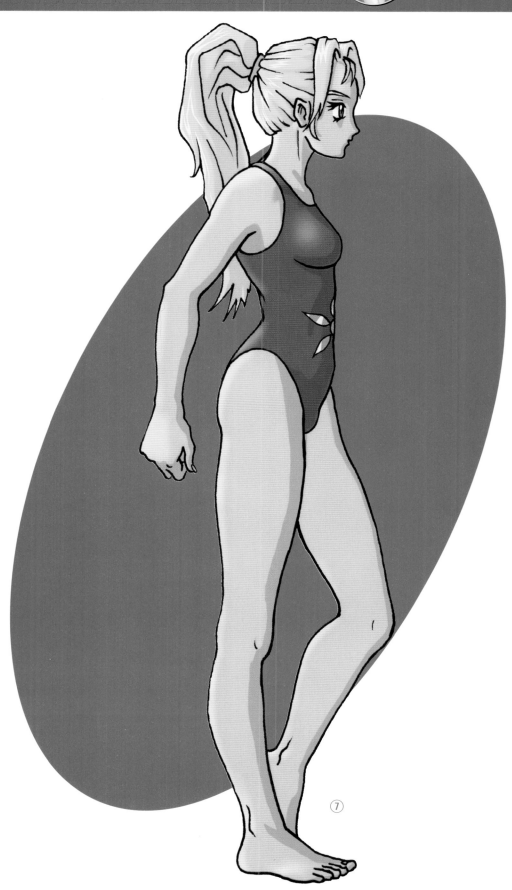

⑦

¾ View

In addition to standing at a different angle, Daisy has changed her pose again, so she now appears as if she is walking.

Step 1

Using light pencil lines, draw the head, chest, and hip shapes as shown. Draw a curved vertical line on each of these body parts—notice how all the lines curve out to the right. Add the lines for the neck and lower part of the spine—these also curve. Add the bones and joints of the limbs. Notice that the upper part of one of the arms is slightly hidden by the chest. The lines for the legs should cross over each other as shown. Copy the shape of the back foot to show how Daisy's heel is raised.

Step 2

Add the main lines that mark the flesh and muscle around your skeleton framework. When you are drawing Daisy standing at this angle, one of the neck guidelines is farther away from the guideline for the spine than the other one. The same will be true for the waist in the next picture.

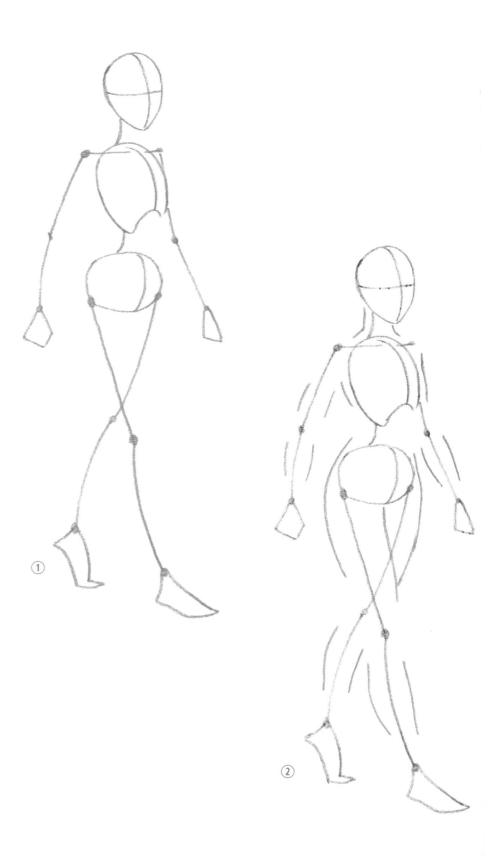

Step 3

Fill in all the gaps around Daisy's body outline, including the hands and feet. Now add the lines for her chest, hair, eyes, and mouth.

Step 4

Draw in the lines of Daisy's swimsuit. Give the fingers and toes some definition, then work on the hair and face. Look back at page 16 if you need reminding about how to draw these.

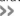

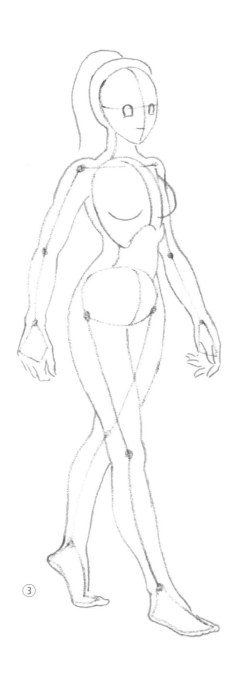

③

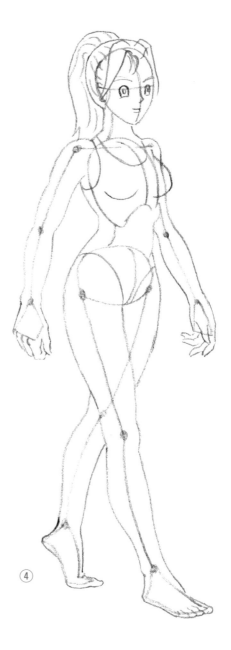

④

<<

Step 5
Go over Daisy in heavy pencil. Draw the flower on her swimsuit—you can see almost all of it from this angle. Don't forget all the little lines on Daisy's neck, rib cage, elbows, knee, and ankle. Add in her fingernails and big toenails. Spend some more time on Daisy's face, especially her eyes. Use a black ballpoint or felt-tip pen to go over all the final lines of your drawing.

Step 6
Once the ink is dry, erase any remaining pencil lines.

⑤

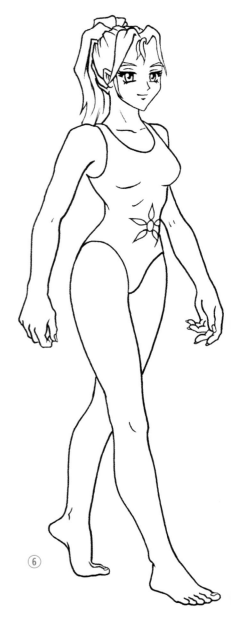

⑥

Step 7

This is quite a sophisticated picture, so if your finished drawing looks anything like this, you're doing really well. If you haven't gotten it perfect, don't worry—that's normal! Try to work out where you've gone wrong and then have another go at it.

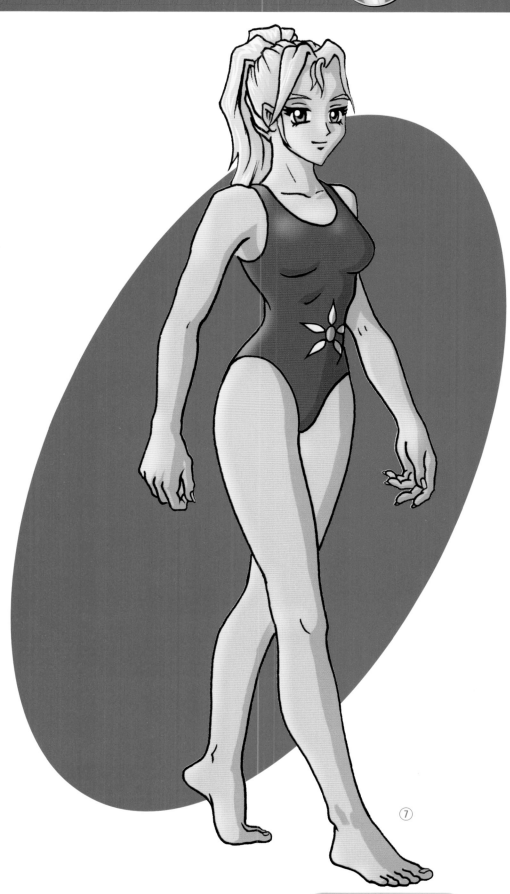

⑦

Hands

Hands are not easy to draw, but mastering how to draw them will give your pictures an expert quality. Just like the rest of the body, they can be broken down into basic shapes.

Step 1

To draw the back of the hand, you need to draw a rough outline of the overall shape before you add the individual bones—the shape is a bit like a fan.

Step 2

Draw a large circle at the bottom to form the wrist bone, then draw the finger bones and joints radiating out from this. The bones are the straight lines and the circles are the joints. The thumb sticks out to the left of your original shape.

Step 3

Draw around the bones to add the flesh and muscle. Make the outline more curved around the fleshy parts of the thumb.

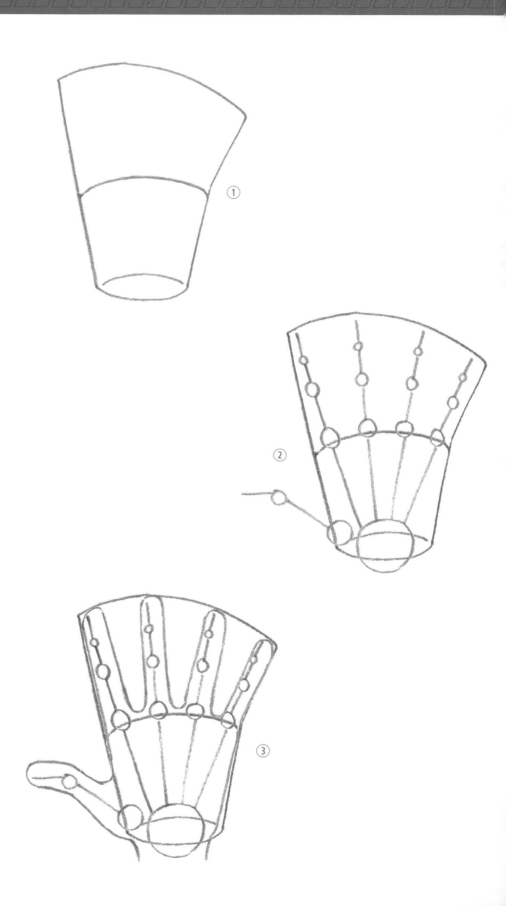

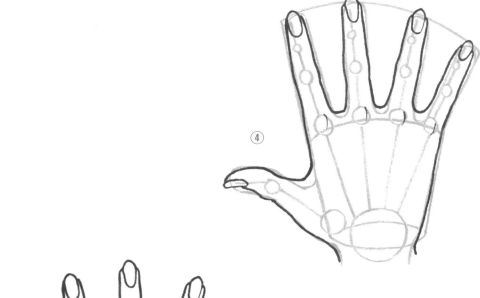

Step 4
Draw on the fingernails and some little lines to define the knuckles.

Step 5
Use a black ballpoint or felt-tip pen to go over the final lines of your drawing again. When the ink is dry, erase all the pencil lines of your original framework.

To draw the palm side of the hand, reverse the drawing you did in steps 1, 2, and 3, then copy all the crease lines you can see here.

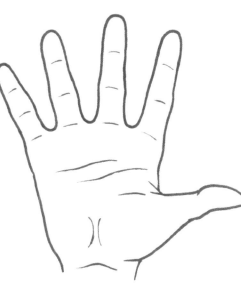

Artists often use their hands as models. Practice drawing your spare hand. Try rotating it so you can draw it from different angles. Look at it in the mirror too.

Hands in Action

There's not much a person can do with their hands if they keep them flat all the time, so you will need to learn how to draw hands from all kinds of different angles, in all sorts of positions.

① Poses

Here are a few examples of Daisy's hands in action. I've added some guidelines to help you work out how they are constructed.

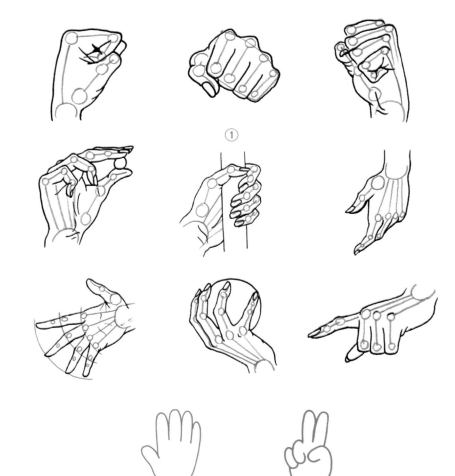

② Simplifying hands

Cartoonists have many different ways of simplifying hands. Try out each of these styles. However you draw them, hands must always look like they belong to the body they are attached to.

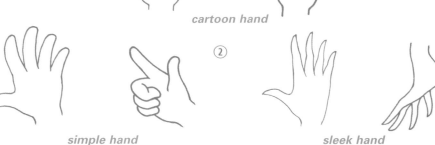

cartoon hand

simple hand

sleek hand

③ Different ages

It's obvious that these hands belong to characters that are very different in age. The baby's hands are chubby, so the bones and joints aren't very defined. The older hands have less flesh, so they look much more bony and wrinkled.

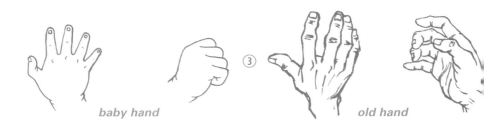

baby hand

old hand

Feet

Feet are made up of just as many bones as hands. Although your manga characters will often be wearing shoes, they will sometimes be barefoot—if they practice martial arts, for instance.

① Daisy's feet

Here are Daisy's right foot and ankle drawn from different angles. Try copying them. I've used circles and lines to mark some of the main parts that form their structure. The two main bulges on the foot itself are the ball and heel. Notice that the two bones that jut out on either side of the ankle are not directly opposite each other—one is higher up. And just like the bones of the hand, the toe bones run in lines along the feet, radiating from the ankle.

② Feet inside shoes

Even when you are drawing characters with their shoes on, it will help you to imagine the shape of the foot inside the shoe.

③ Basic shapes

Try to think of feet as triangles to begin with. If you get this basic shape right, the other details should fall into place.

④ Simple feet

Even if you decide to simplify the feet, it's still important to get their basic shape right. The toes should form a pointed shape, as in the first picture. If you draw them like they are in the second picture, they will look too square.

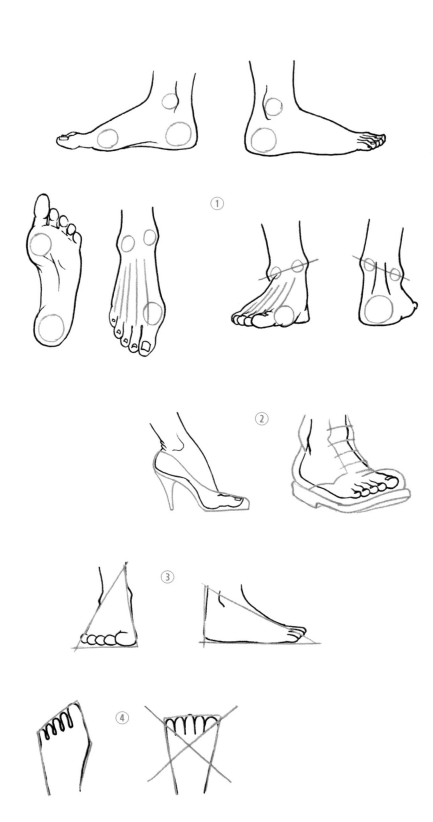

Proportions

Earlier in this book, we looked at how the proportions of the head change as a person gets older. The same is true of the body. Manga artists work out the relative sizes of their characters using head lengths. These pictures show Daisy at four different ages.

① **Toddler Daisy**

The younger a character is, the larger her head will tend to be in relation to the rest of her body. At about three years old, Daisy's whole height is four times the height of her head. Manga children of this age are much chubbier than manga adults.

② **Preteens**

At around nine years old, Daisy is about six heads in height. Her body is more shapely than when she was younger, but she is still quite skinny.

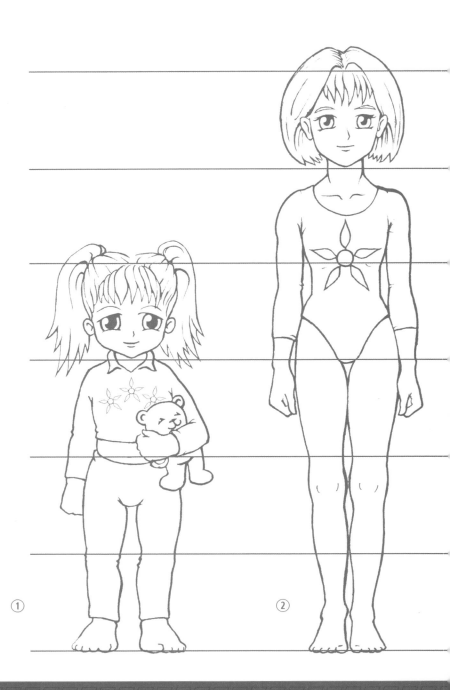

①　②

③ **The teenager**

Daisy is now 17, so she is nearly fully grown. She's seven heads tall—some manga adults are also around this height. Daisy is tall for her age to make her look more glamorous. Compare Daisy here with the pictures of her when she was younger and see how much more developed her muscles are now.

④ **Adulthood**

This is Daisy at her fully grown adult height of eight heads. Not only is she taller, but her body is broader at the hips and her limbs are more curvy. Real human beings are rarely eight heads tall, but this is very common in manga stories. Sometimes characters can be as tall as 10 heads, but they tend to be male characters, and only the extra-strong or evil ones. Manga females of eight or more heads in height are usually fashion models or action heroines.

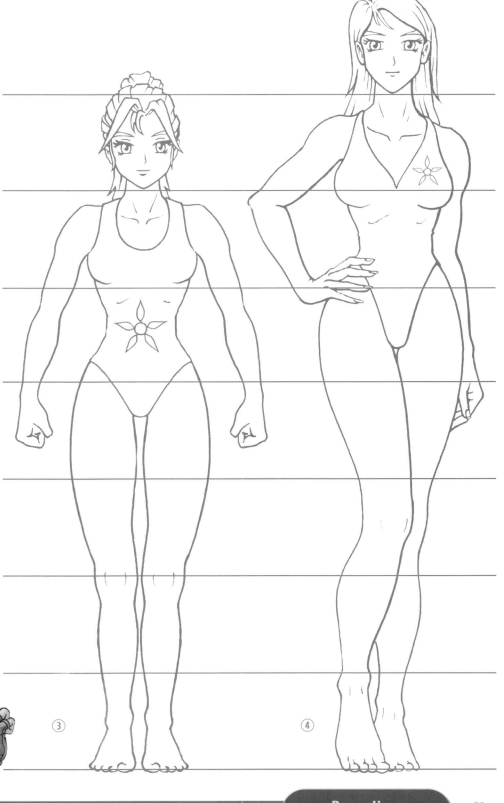

It is uncommon for female characters to be heavily muscled, even if they are dynamic action types. Their bodies are more often tall and graceful.

③

④

Clothing

Every item of clothing will fall, fold, hang, and wrinkle slightly differently because of its shape and material.

① Everyday clothing

The clothing here is quite baggy. This emphasizes the effects of the body's movement upon it. Where the limbs are bent at the knees and elbows, the cloth gathers into tight folds. Where the limbs stretch, the cloth is pulled tight but still forms wrinkles. Notice how raising an arm causes the fabric under the armpit to form folds that radiate away from the joint. In places where the cloth is not pulled or gathered, it hangs more freely.

② Tunics and capes

Manga characters are often dressed quite differently from real people. They might have flowing garments like tunics and capes. When the character is standing still, all the folds will hang vertically due to the pull of gravity. In this sketch, even though I haven't drawn the body, you can tell there is movement or wind affecting the cape, causing the folds to flow in different directions.

③–⑤ Materials and shape

It is essential to think about the weight of the cloth. A thicker fabric, like in picture 3, makes bigger folds. Folds also occur where the fabric is loose-fitting, like in picture 4. Manga characters often wear tight-fitting clothes which have simple wrinkles, like in picture 5. These are easy to draw—as long as you have drawn the body underneath them well.

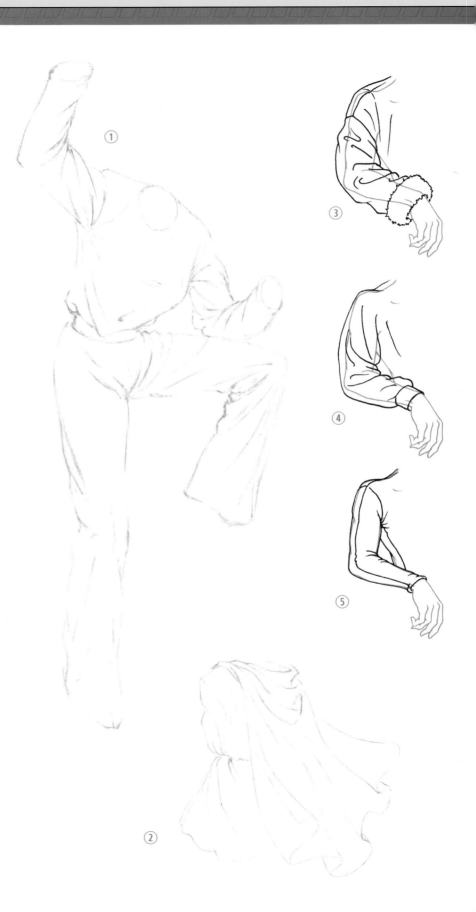

Manga Style

The clothes you choose to give your manga characters can say a lot about their personality and status as well as when and where they live. Here Daisy has been let loose in a manga clothes store and she is modeling some typical manga outfits. There is not much detail in these drawings and no color or texture, but you can still tell from the folds and creases that they are made from different materials and that the style of the clothing also affects the way it hangs on her body.

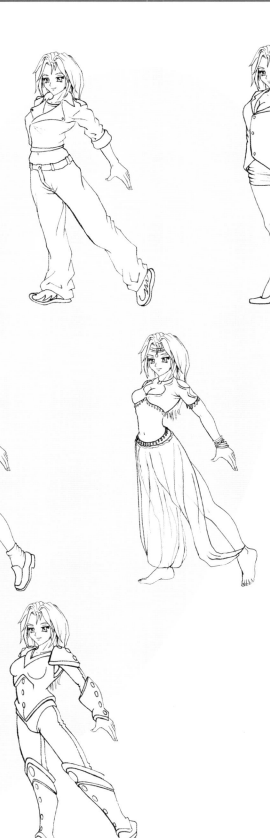

COLOR

Now that you've built up a batch of drawings, you might like to learn a few different ways of enhancing them with color.

The world of color is very rich and complicated—the human eye can distinguish millions of subtle color variations.

Here we're going to look at inking your drawings, coloring, and applying tone. You'll also learn about how colors work together.

Experienced artists have their own preference for using certain materials depending on their style and what they enjoy working with most. The best way to find this out is to experiment with different materials to learn if you like them and the different effects they can create.

Colored pencils are easiest to use so you may want to start with them and then move on to felt-tip pens and watercolor paints. When you are working with paints, use thicker paper since it won't tear when it gets wet.

I'll also tell you about computer coloring—but If you don't have access to a computer, don't worry. Comics were around years before home computers existed, and older manga artists produced beautiful artwork without using them at all.

Art materials can be very expensive, but you can get by quite well with just a few of them. All the examples in this book are done with the kinds of materials you might even have already. So, let's start coloring.

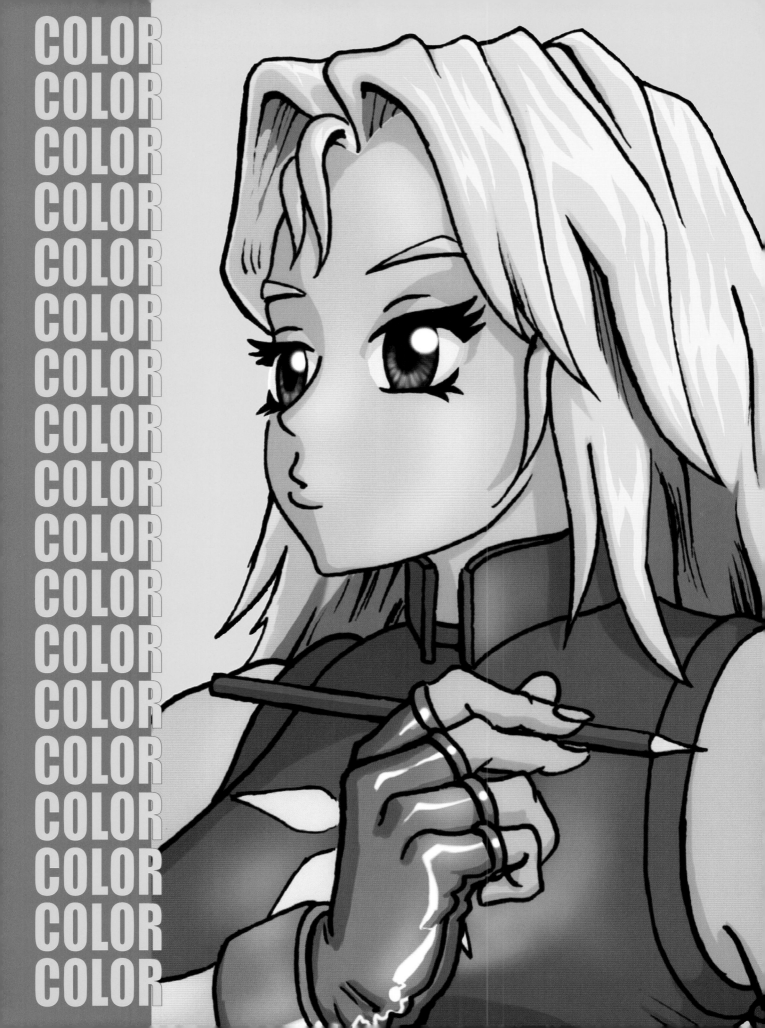

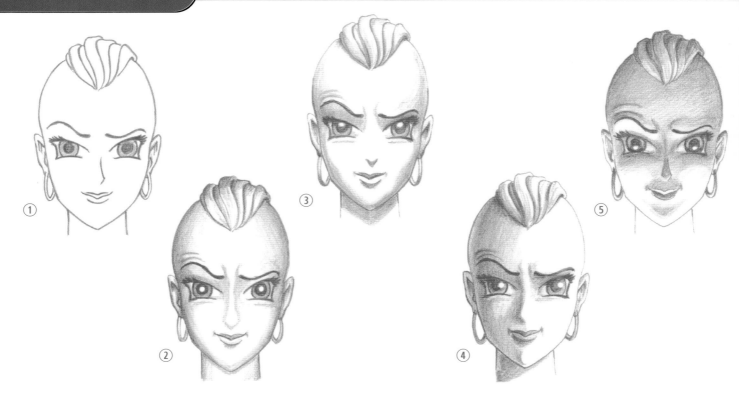

Light & Shade

Pencils are great for drawing lines, but they are also good for shading. Making some parts of your drawing darker will create the illusion of solidity and depth. Think of shading as coloring in black and white, but don't get too carried away with your pencil—leave plenty of white paper showing. The lighter some parts are, the darker and more dramatic the shadowy areas will look.

① **Line drawing**
This is Atta. Her face is drawn in simple pencil line. The only shading is on her irises and pupils. It looks fine, but it could be made much more interesting by using shading to show how the light is falling on her. When light falls on an object from different angles, it brings out different aspects.

② **Front lighting**
Imagine that light is falling on Atta directly from the front. The center of the face, where the light hits full-on, will naturally be better lit than the top of the head and the sides of the face, where the light hits at sharper angles—these areas should receive the heaviest shading with your pencil. Using a soft pencil, start by shading very lightly and gradually build up the darker areas layer by layer. Notice how the highlights in the eyes have changed position— they should always face the direction from which the light is coming.

③ **Lighting from above**
Now the light source is above Atta so the top of her head has the least shading. Notice how the shading is darker below the brows and under

the chin since shadows would be cast on these parts of the face.

④ **Lighting from the side**
The light source is to the right of the face. The areas of heaviest shading are on the side away from the light.

⑤ **Lighting from below**
You can use lighting to make a picture much more dramatic. When the face is lit from below, it takes on creepy qualities.

⑥ **Adding backgrounds**
When you put the shaded drawings of Atta against a dark background, this makes the effects of shading her differently much more easy to see.

COLOR

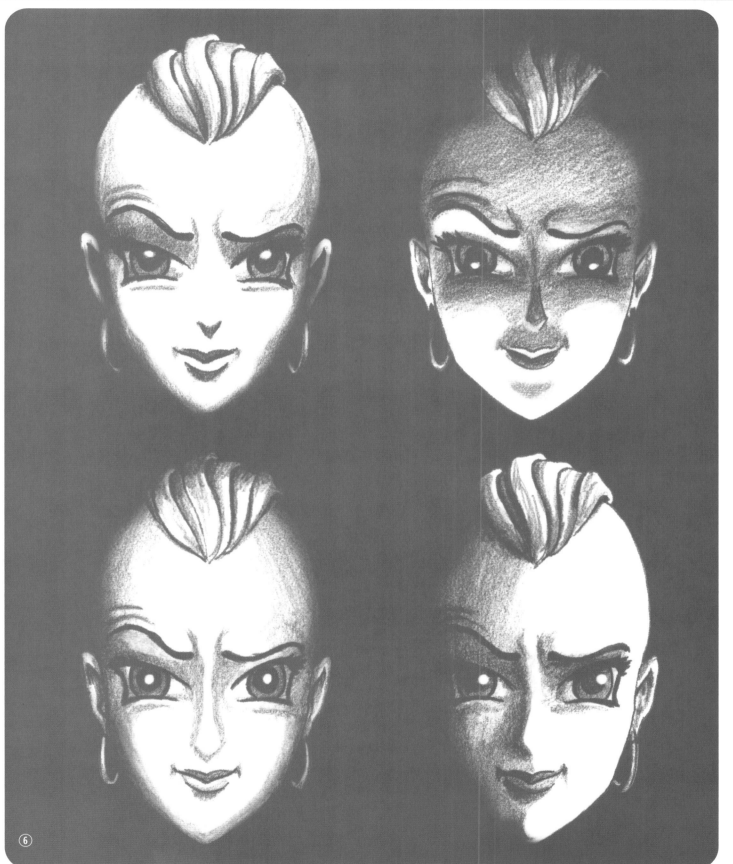

⑥

Light & Shade 59

Inking & Coloring

This is Penine. Here I've used different materials to shade, outline, and color her to show you some of the results that can be produced.

① Pencil

In some areas of this picture the shading is lighter than it is in other areas. This is because I have imagined that Penine is lit from above. You can see that pleasing effects can be achieved without any pen or dark outlines.

② Simple pen line

Manga comic drawing is usually outlined in ink. Here I've drawn the lines of my picture using a fine-tipped black pen—the kind that you can buy quite cheaply from any art or stationery store. Once the ink is dry you can easily erase your unwanted guidelines.

③ Finished pen line

Traditionally, manga artists use a metal pen, which they dip into a bottle of black ink. This kind of pen can produce lines of varying thickness, depending on how hard you press the pen against the paper, but the pen and ink can be tricky and messy to use. A similar effect can be created more easily using ordinary felt-tip pens as I have used for all the finished ink drawings in this book. Retrace your simple pen lines varying the width of the lines and emphasizing curves. Where the lines are facing away from the light source or they are in the shadow of the hair, I've made the lines bolder.

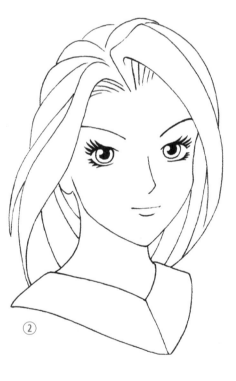

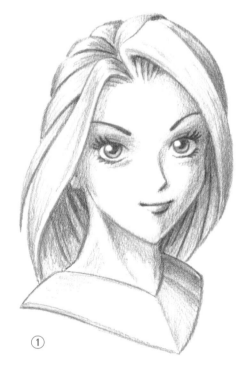

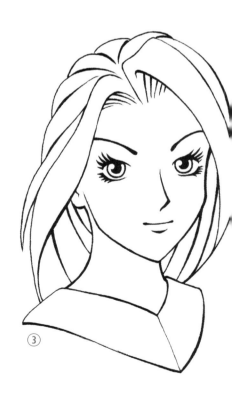

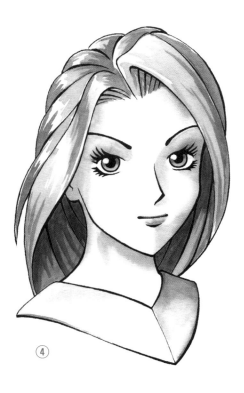

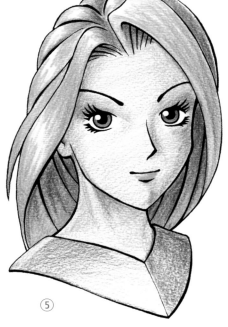

④ Tonal wash

Now that you have a good solid outline, there are different ways to finish your picture. For this illustration I mixed black watercolor paint with a lot of water to make it thinner and easy to apply. This technique is known as *wash*. You can use watered-down ink instead if you like. To paint like this, make sure the outline was done in waterproof ink; otherwise, it will blur when you apply the paint. Work on fairly heavy paper because thin paper will buckle under the wet paint. You'll need a brush. It is worth investing in a quality one, with soft hairs and a fine point. Good brushes are not cheap, but for most pictures you only need one, and if you clean it carefully after each use, it will last for hundreds of pictures.

⑤ Colored pencils

The easiest way to add color to your pictures is with colored pencils. Although they will not give you really professional results, they are easy to use and can look good if you use them well. Colored pencils are especially good for quickly sketching new color schemes in rough. They also allow you to blend colors to create new colors. For this picture, my pencils didn't give me exactly the shade I wanted, and so I blended in other colors by working one color over the top of another.

⑥ Felt-tip pens

Another medium you may have used before is colored felt-tip pens. These produce vibrant results very quickly and they come in a vast range of colors. Felt-tip pens of artist's quality are very expensive indeed, so unless you have a lot of spare money and you are extremely committed to manga artwork, it's not worth investing in them—you would be better off with the cheaper variety. A few strokes of white ink can be applied on top for highlights. White ink can also be useful for correcting mistakes.

Color Theory

There are a few basic rules to follow when you're using color and they will make all the difference to the overall look of your finished artwork. Here's Daisy to demonstrate.

① **Primary colors**

Red, blue, and yellow are the basic colors that all other colors are mixtures of. These are called *primary* colors, and I've used them for Daisy's clothes here. If you can only afford three colored pencils, pens, or paints, these would be good ones to buy.

②–④ **Secondary colors**

The next range of colors are green, orange, and purple. These are called *secondary* colors. Each one is a combination of two primary colors. Here the colors of Daisy's pant legs are the ones that would be mixed to make the color of her shirt.

⑤ **The full spectrum**

The three primary and three secondary colors represent the full spectrum of pure bright color, like you would see in a rainbow. If you use them all in one drawing, you can see that the result can be quite overpowering, so don't use too many different colors in one picture.

⑥–⑦ **Tints and shades**

White and black can also be added to a color to change its qualities. Colors that have had white added to them are called *tints* and look pale and pastel, like in picture 6. Colors that have had black added to them are called *shades* and look darker, like in

picture 7. Using tints and shades will make your pictures look much more sophisticated.

⑧ **Complementary colors**

Some colors go better together than others. Good combinations can be made by using *complementary* colors. Each primary color has a secondary color as its complement which is a combination of the other two primaries. So red is complemented by green (a mixture of blue and yellow), blue is complemented by orange (a mixture of red and yellow) and yellow is complemented by purple (a mixture of red and blue). Here Daisy is dressed in various tints and shades of yellow and purple. She has even dyed her hair to add to the effect.

⑨ **Harmonious color schemes**

You don't need to use many colors at all to create a harmonious color scheme. The only color used for Daisy's clothes here is red, which has been turned into different tints and shades by adding white or black.

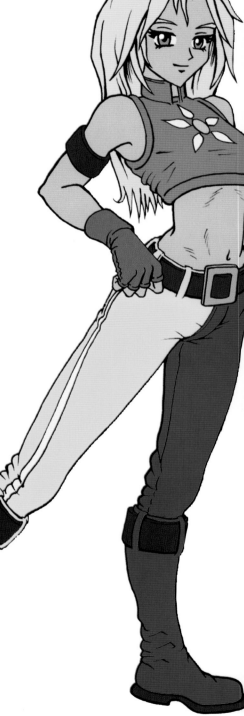

①

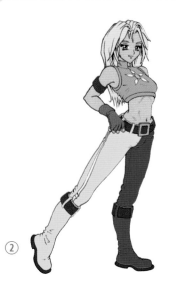

②

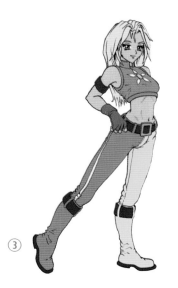

③

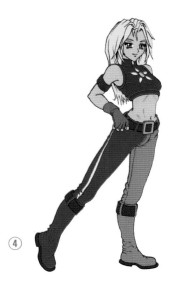

④

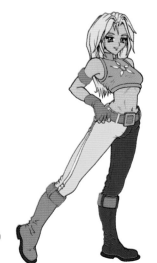

⑤

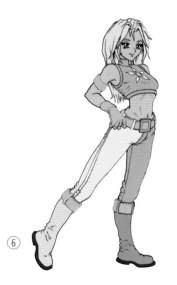

⑥

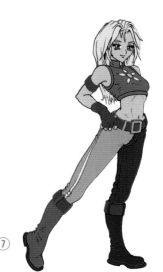

⑦

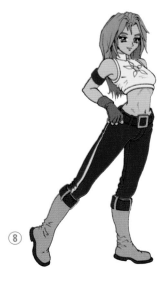

⑧

⑨

Computer Coloring

Virtually all manga artwork is colored by computer these days, and perhaps one day it will all be done with computers. It takes a while to learn, but the principles are quite simple. There are various software packages that you can use—to follow this exercise you'll need Adobe Photoshop. Remember to save after every stage.

Scanning and preparation

First draw your picture. Once you have a line drawing you are happy with, you need to scan it in order to convert it into a digital file for the computer. It's best to scan your picture at a high resolution— say 500 dpi—and as a grayscale image. This will give you crisper lines later on. When you open the image in Photoshop, reduce the resolution down to 300 dpi. That's about the maximum you'll ever need to print with, and larger sizes will only slow down your computer.

Convert the image (in Image>Mode>) to RGB. This allows you to start using color. This is a good time to look at your work close up and clean up any blotches you find. There's no need to be too compulsive though—as long as you sort out the biggest imperfections, most people won't notice any small blemishes. Use the Eraser tool for this.

Making sure your background color is white, choose Select All (Apple + A) and then New Layer Via Cut (Apple + Shift + J). Set the Blending Mode of this layer to Multiply, name it Line Art, and then Lock it. You shouldn't need to touch your original artwork again.

Hint: I use an Apple Macintosh computer, for which the command key is labeled with an Apple symbol. If you use a P.C. the same function is achieved with the control key labeled 'ctrl'.

Eraser

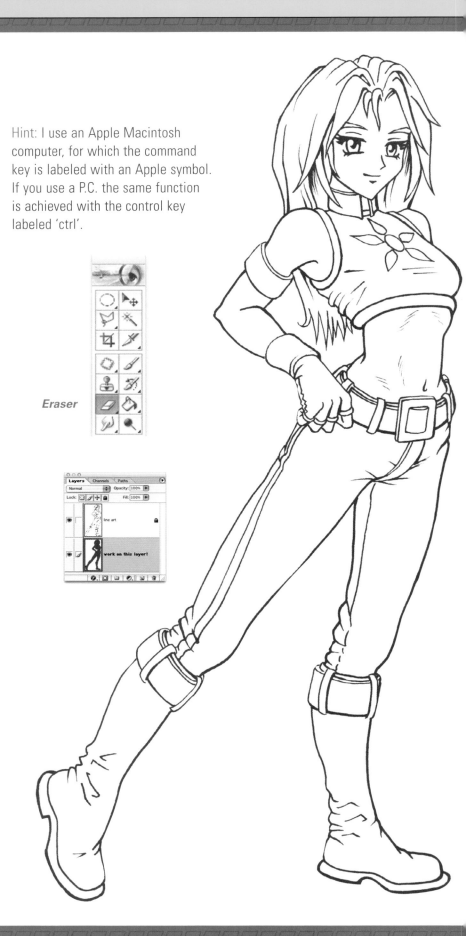

① First color

You will apply the color (called Flat Color) on the layer below that of your original line artwork. Start with the color that makes up the biggest area of your figure—here it's Daisy's pants, and I'm using a medium blue-gray for them. You need to apply this color to the whole of your figure to separate the figure from the background. You'll change different areas to other colors in a little while.

To apply the gray, magnify your image, then use the Polygon Lasso tool to select the area. Now fill it up using the Bucket tool.

② More colors

Now you need to change part of your figure to the color that makes up the next largest area of your figure—in our example it's Daisy's skin color. Use the Polygon Lasso tool again, then fill the area using the Bucket.

Or change the color using Image > Adjustments > Hue/Saturation (Apple + U). Repeat this process, selecting smaller and smaller areas each time. Hint: Once you've drawn out your rough selection area, you can use the Magic Wand with the Alt key pressed down to deselect any differently colored areas that you may have included accidentally; this will keep your work neat and tidy.

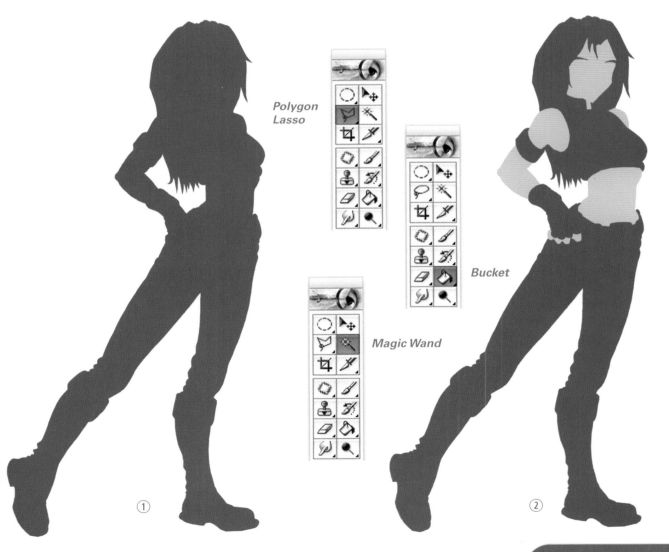

Polygon Lasso

Bucket

Magic Wand

① ②

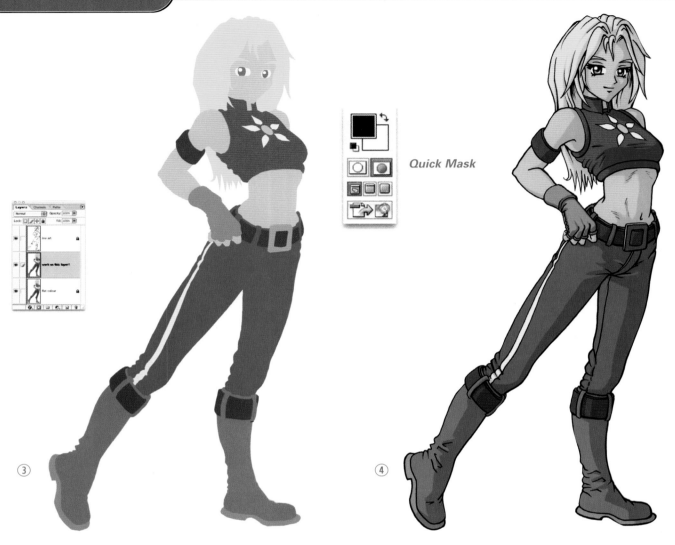

Quick Mask

③

④

③ Saving the flat color

Once you've got all the flat color down, select New Layer Via Copy to copy the layer. Name the new copy of the layer (which will appear at the bottom) Flat Color, then Lock it. You shouldn't need to change this layer again, but it will prove useful with the Magic Wand tool later on. You should have been saving your work regularly, but save now if you haven't already.

We'll only work on the layer in the middle from now on. Picture 4 shows the same stage with the outline.

④ Adding shadows

Now it's time to add some shadows. For this, we'll be using Quick Mask. Click on the Quick Mask icon or press Q. Using the Brush tool, paint an area you want to be in shadow. Don't worry about going over the lines—we'll fix that in a little while.
Hint: To make Quick Mask easier to use, double-click on the icon in the tool palette to view its Options palette. Check Color Indicates: Selected Area and choose a dark mask color. To see what you've just done, leave Quick Mask mode (press Q again or the icon in the tool

palette). You'll see that you've selected an area of the image. For a more feathered selection you can use a softer brush. Now you can clean up the selection by going to your Flat Color layer and using Alt plus the Magic Wand tool as you did earlier.

Go back to your working layer (the middle one) and use Image > Adjustments > Hue/Saturation to shade to your taste, or just fill it up with the Bucket tool.

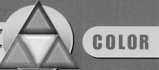

⑤ Highlights

You can use the same technique you used for the shading to make well-defined areas of light and dark. This is how I worked on Daisy's hair.

Hint: If you would like exact control over the area of highlight, instead you can magnify the image and use the Lasso tool to select the shapes you want. For most of the images in this book, I used the Dodge tool, which softly lightens colors wherever it is applied. If you prefer a more painterly style of shading, you can use it and the Magic Wand to mask off the areas you're working on.

Your work should now be ready to print out.

Dodge

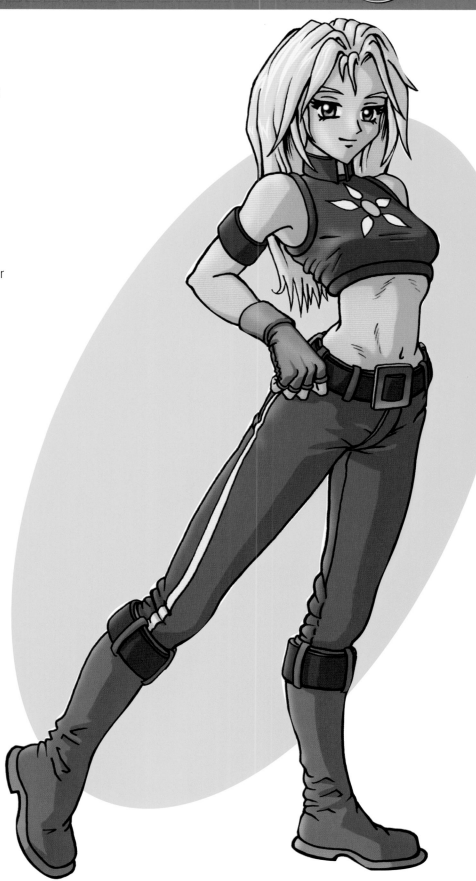

⑤

ACTION

apturing the movement and look of a character's body and clothing is the key to drawing convincing action figures.

Getting these right has a lot to do with studying features closely, so in this section I'll get you to think more about body language, movement, and perspective.

I'll also introduce you to the technique of foreshortening to enhance your pictures.

There are plenty of opportunities for you to put the theory into practice too.

Here it is more important than ever to start with light pencil lines that you aren't afraid to change until you get your picture right. So let's get down to some action.

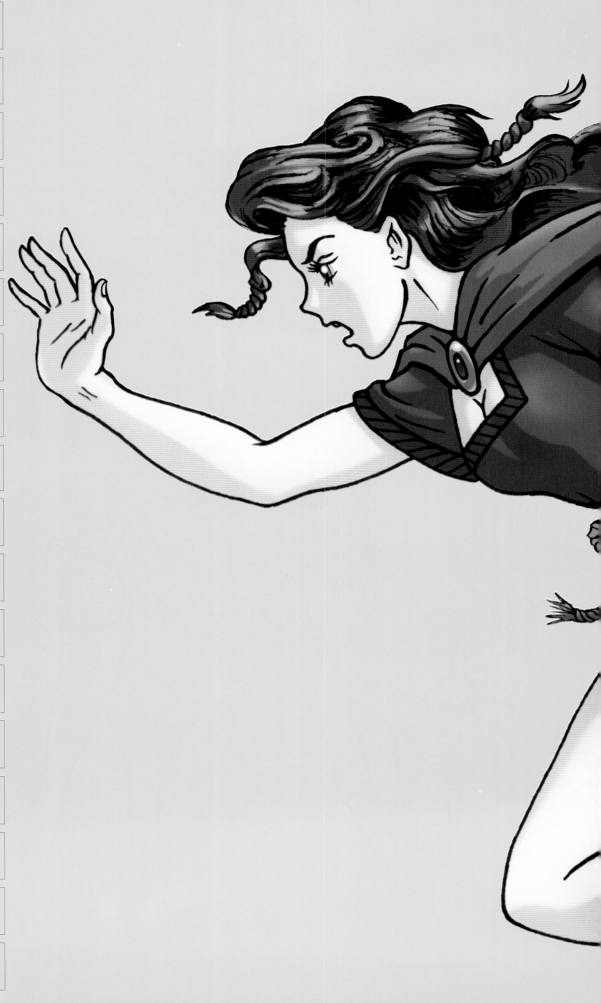

Body Language

Everyone displays body language in everything they do throughout the day. Often this can be quite subtle, but in manga, there's no place for subtlety! In each of these rough sketches, the character has no facial features, but she is still showing a lot of emotion through her pose. Try copying some of the poses, or choose one of the poses to apply to your own manga character.

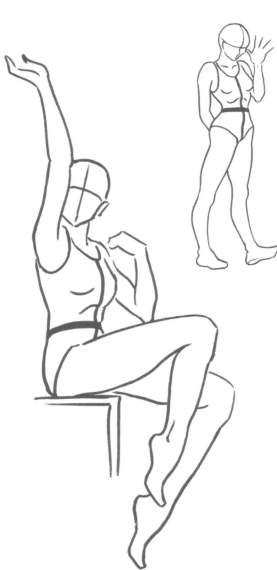

Movement

The pose of the body doesn't just convey the mood of a character—it can also be used to show movement and action. There's a whole range of poses you can devise for manga figures, but to make the figures look realistic, they should only bend in the same way that a real person's body bends. Shoulders, wrists and ankles can swivel in many directions, for instance, but knees and elbows can't bend backward or sideways. Use your own body to try making a pose you want to draw to see if it's really possible!

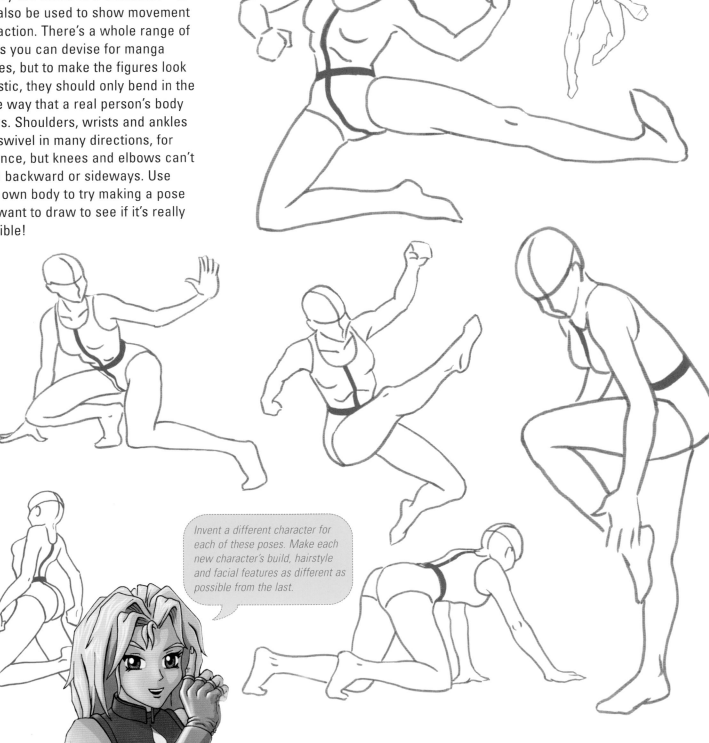

Invent a different character for each of these poses. Make each new character's build, hairstyle and facial features as different as possible from the last.

Flirting

In manga, poses are often exaggerated for dramatic effect and the following drawing is no exception. Tellima is standing sideways on but she has turned around to face us, so her body is twisting.

Step 1

Draw a long vertical line, then copy the angle and position of the ovals for the head, chest, and hips, noting where each one crosses the vertical line—the oval for the hips is farther to the left than the top two ovals. Because each part of the body is at a different angle, the vertical guideline on each oval is positioned differently. Now for the limbs. Because of the angle of the hips, you'll have to just imagine where the far leg joins the hips. The positions of the shoulders are quite difficult to work out too, so copy the picture as carefully as possible. The feet should be angled so that it's clear Tellima is standing on tiptoes.

Step 2

Since you've already had some practice at drawing manga bodies, you should now be ready to draw the outline of Tellima's flesh in one stage. Copy the red lines.

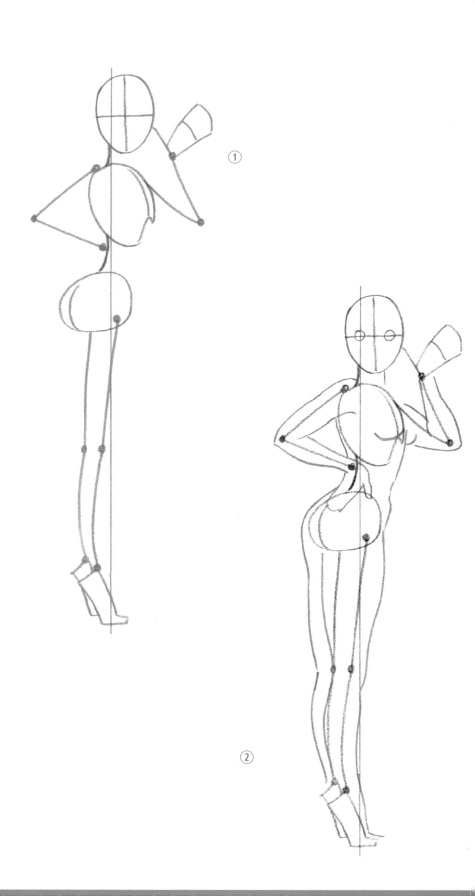

Step 3

Map in the basic shapes of the clothing and hair. Notice how the sleeves finish just below the elbows. The outline of the skirt is almost triangular in shape. Give the hands and feet some more attention, shaping the fingers and toes. Work on the chin and some of the facial features. Add the basic outline of the hair.

Step 4

To draw clothing convincingly, you need to capture the direction of the folds—just as drawing hair convincingly means capturing the way it flows. Add some curved lines to both the skirt and hair, as shown, to give the impression of movement. Draw some crease lines inside the elbows, under the armpit, and on the socks.

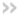

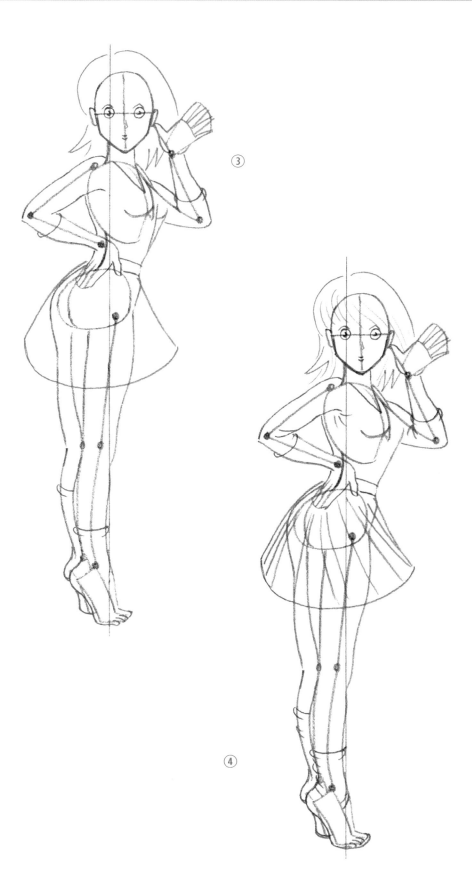

③

④

«

Step 5

Now you can enjoy establishing the final drawing using a black ballpoint or felt-tip pen. Finish off the eyes and hair. There are all sorts of details you can add to your picture here—try drawing a bracelet on Tellima's wrist to add to the sense of movement. Work on the folds of the skirt, drawing some curves along it's hem. Add more detail to the socks too to show their loose-fitting shape.

Step 6

Once you're sure the ink is dry, erase all the pencil guidelines to reveal your finished line drawing.

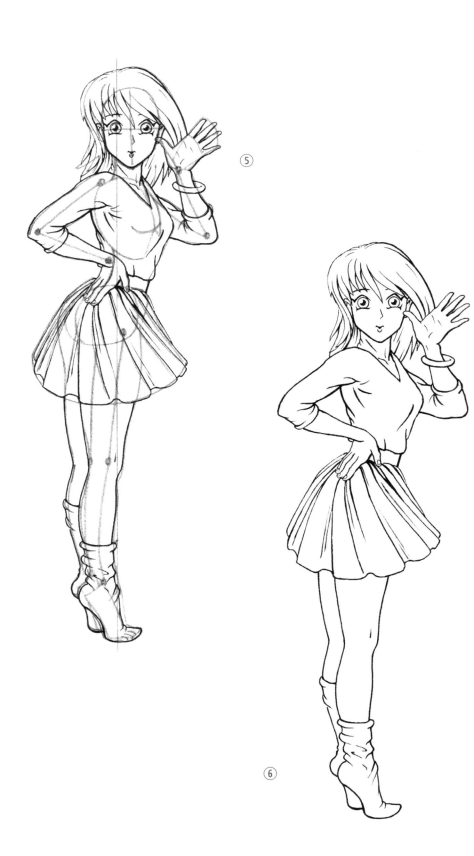

Step 7

You could copy this color scheme to complete your drawing or design your own. Look back at the Color section to help you get started.

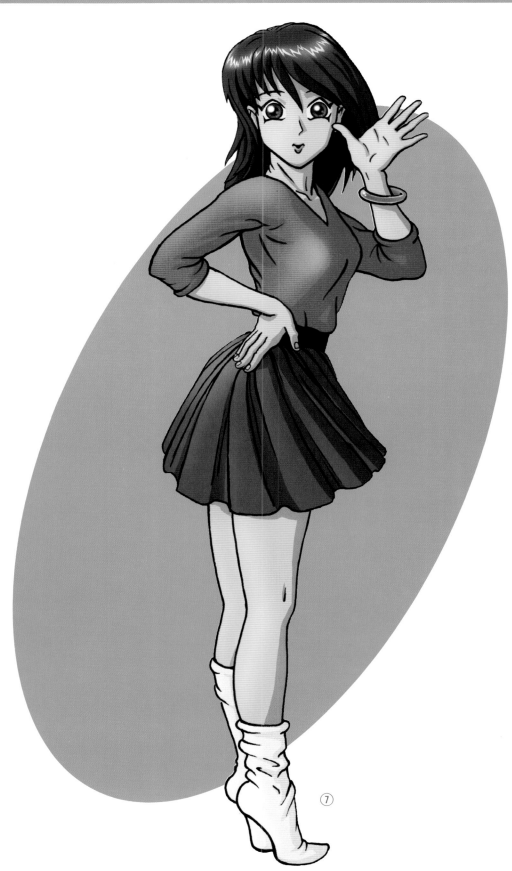

Running

If you use all the techniques you have learned so far, you'll find this drawing much easier to construct. The main thing about this pose is that it's not balanced—if you tried to stand like this yourself, you would fall over. That imbalance helps give the impression of movement, together with the flowing hair, skirt, and cape.

Step 1

Draw the three main body parts of Lunara's skeleton first. You are drawing her body from the side but with it leaning forward so the body parts follow a diagonal line. Don't make the head too large. Now add the limbs. Lunara is very tall, so her arms and legs are extra long.

Step 2

Draw the outline shape of Lunara's flesh and muscle. Notice how there are strong curves in the shape at the backs of the legs to show Lunara's strong muscles.

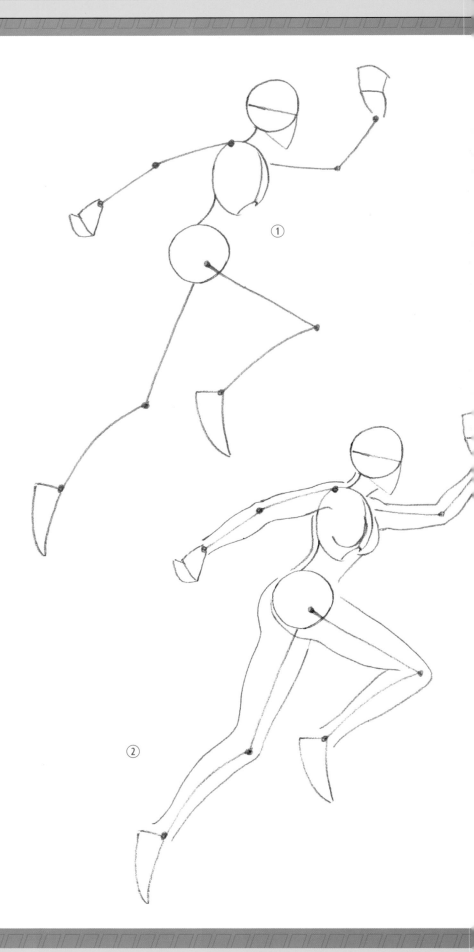

Step 3

Add some basic lines for Lunara's tunic and cloak—study the finished picture on the next page and compare it with this one so you are clear about what you are drawing. Add the main features of the face and some of the curves of the hair. Work on the shape of the feet.

Step 4

Give the clothing more detail—notice the square-shaped neck of the tunic. Add a belt, then draw some lines along the bottom of the skirt and cloak to show the folds. Work on the hands and feet—Lunara is wearing sandals, so you'll still be able to see her toes in the final picture.

>>

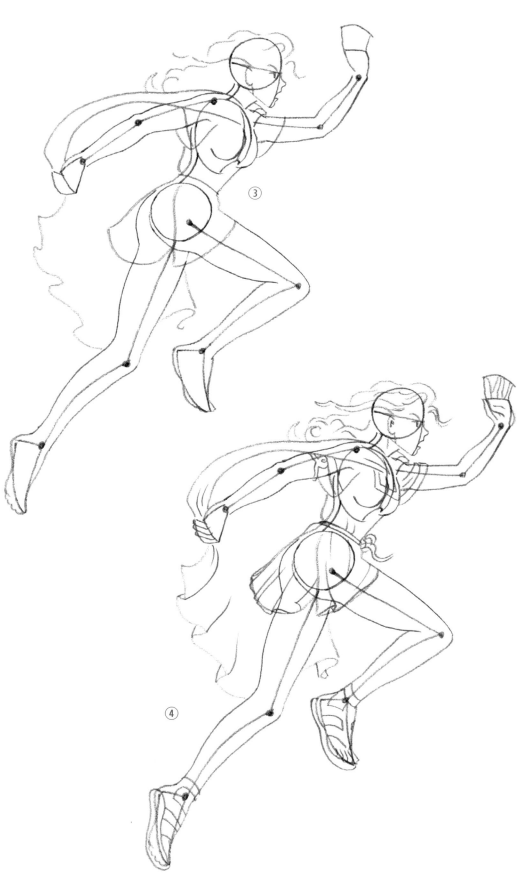

<<

Step 5

Once you're happy with your drawing, go over your pencil lines in black ballpoint or felt-tip pen. Now add some shading to the hair to give it more depth. Notice how I've created some braids in the hair. I've also worked on the design of the neck of the tunic and secured the cape with a brooch. I've turned the belt into a piece of rope and put a buckle on the outside of one of the sandals. Rather than simply copying this, why not make adaptations of your own—you might even decide to change the clothing to make Lunara look more modern or more futuristic.

Step 6

Leave the ink to dry, then erase all your remaining pencil guidelines.

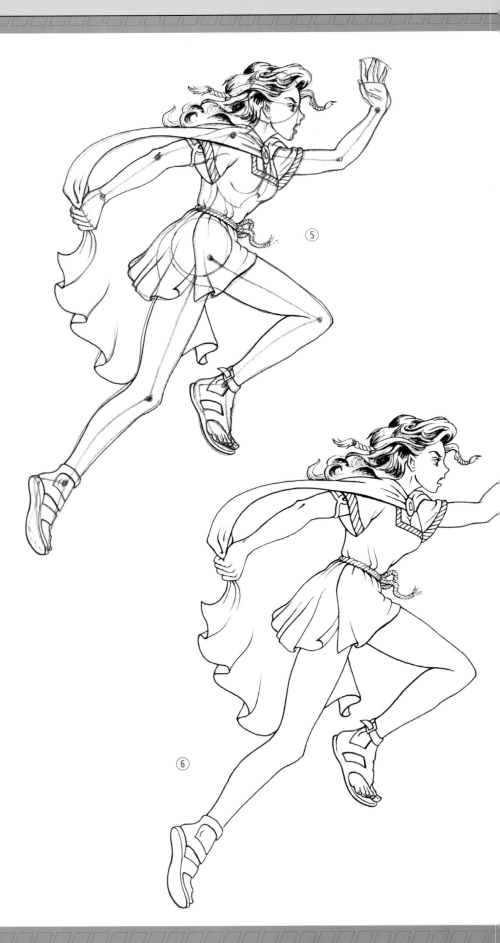

Step 7

Now you can add some color to your picture. I've given her auburn hair and made the skin fair. Notice how dark the inside of the cloak is, where it is in shadow.

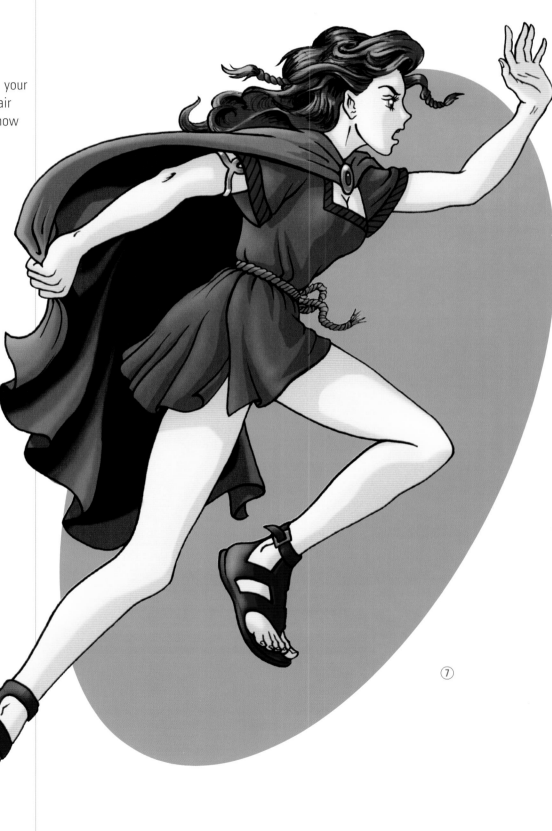

⑦

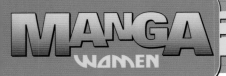

Perspective

When artists talk about perspective, they mean that objects look different according to the angle, the height, and the distance from which we view them. In all the pictures on this page, the figure is holding exactly the same pose.

Figure 1

Notice how when viewed from the front, the figure appears to be resting the box on her foot.

Figure 2

From the side, we can see that the box is actually some distance in front of the figure's feet.

Figures 3 and 4

Looking at our character from behind means the hips are closer to us and so appear wider. Notice how the waistband curves down at the ends—in picture 1, it curves upward.

Figure 5

We are looking down on our figure, so it is below our eye level. This means that all the parts of the picture that look level in picture 1—like the shoulders, the elbows, and the box—now slope up the page, as shown by the blue lines. The farther below our eye level the blue line is, the steeper its slope.

Figures 6 and 7

Here only some parts of the pictures are below our eye level (green line), some are above it, and others are directly at eye level. Some of the blue lines therefore slope up, some slope down, and others are roughly horizontal.

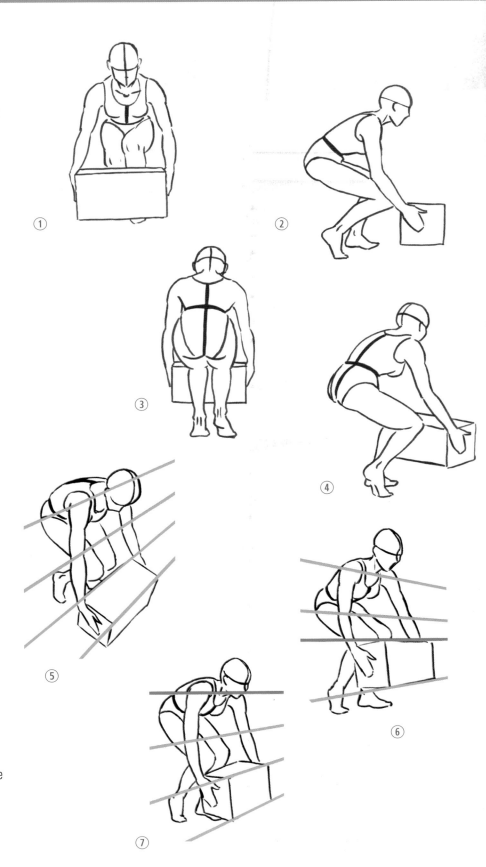

Foreshortening

Another technique that is used to make manga figures look more dynamic is foreshortening. This is when the parts of a figure that point toward us look shorter than the ones we are viewing from the side.

Figure 1

Although the lower legs and feet are missing from this picture, because we know what bodies usually look like, we imagine that from our viewpoint they are hidden behind the thighs.

Figure 2

This figure's upper body has been made shorter to make it look like it is bending forward as the figure runs toward us. The raised shin appears very short, but we accept that both legs are really the same length. We also assume that the figure's hands are equal in size, even though the one pointing toward us is closer and, therefore, larger.

Figure 3

Feet are about as long as the head, but here they are drawn half the size, because they are twice as far away.

If you can't quite make sense of this principle, don't worry—the more you practice drawing figures, the more you'll come to understand it.

Crouching

This drawing involves foreshortening. Our manga character Elise is crouching down. She has twisted her upper body to lean forward and rested one hand on the ground to help her balance.

Step 1

We are looking at Elise from above and she is leaning toward us. We won't see much of her neck and stomach, so make the ovals for her head, chest, and hips overlap each other. When you add the limbs, make sure you slope the collarbones. The bones of the front arm should be made longer than the ones forming the back arm to make it appear closer to us. The hand on this arm should also be bigger. Copy the leg bones carefully—one calf bone is missing since from this angle, the lower part of the leg is hidden.

Step 2

As you draw the shapes of the flesh and muscle around the skeleton, think about the angle from which you are viewing the different parts of the body and how far away from you they should look. The shoulders are not level, and this affects the way the chest curves. The long front arm appears broader than the back one. Carefully copy the bend in the leg to the left of your picture.

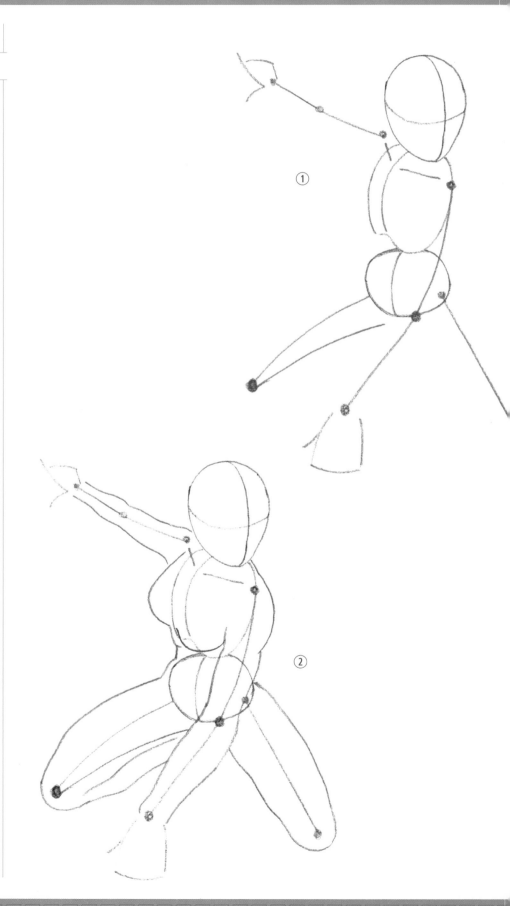

Step 3

Place the facial features—the eyes will not appear level, but your guidelines will help you to place them correctly. Add some guidelines for the hair. Start to mark the clothing—Elise's suit fits her body closely, so you won't need to draw their whole shape. Add the extra details like the knee pads and belt—study the color picture on the next page to help with this. Draw in the parts of the feet you can see.

Step 4

Add some more detail to the face and hair, then work on the shape of the hands. Now add some crease lines to the clothes and a holster around Elise's leg.

»

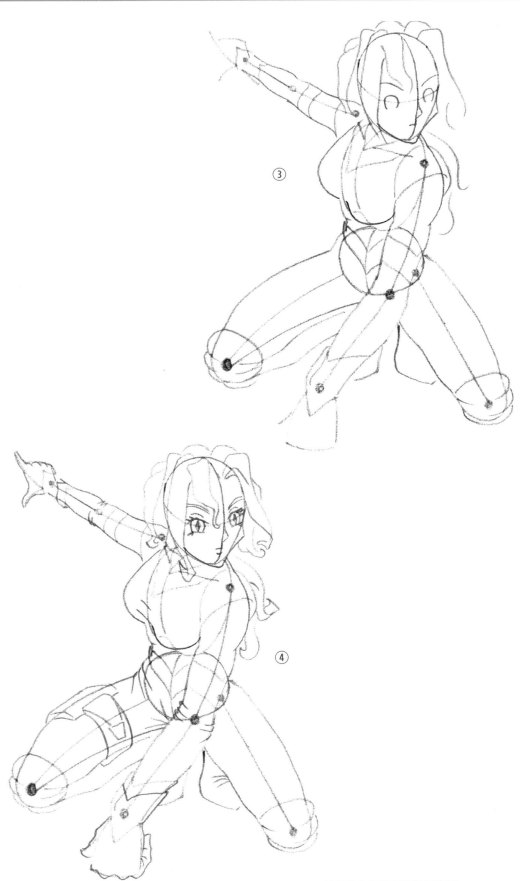

<< Step 5

Go over your drawing with a black ballpoint or felt-tip pen. Add some extra lines to the hair to give it more definition. Take another look at your picture to see if there's anywhere else you think you need to do this.

Step 6

Wait for the ink to dry, then erase all the remaining pencil lines that formed your skeleton framework. If you get this far and you are happy with your drawing, that's great! Drawing manga women doesn't get much more complicated than this.

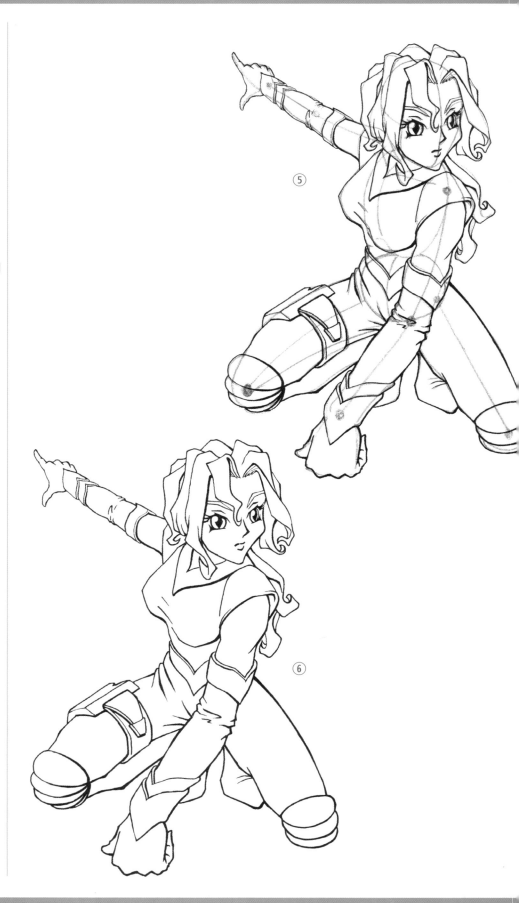

Step 7

Now for some color. I've given Elise a futuristic look by making her hair and eyebrows bright blue. I've used a yellow for the parts of her clothing that should appear metallic. To remind yourself about color schemes, look back at the Color section of this book.

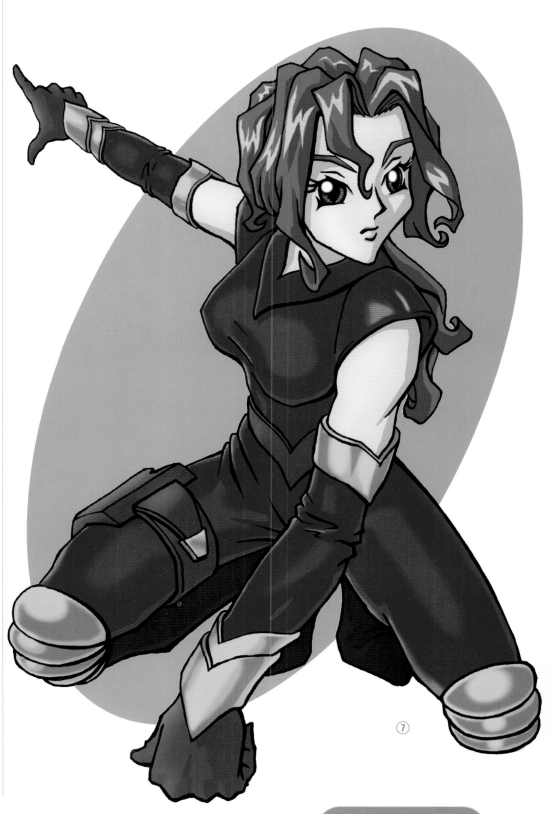

⑦

PROJECTS

In this final part of the book, you will have the opportunity to put together many of the different techniques you've learned so far to make your most advanced manga drawings yet. While you're sketching them, look back at the other sections whenever you feel you need reminding about a particular aspect of drawing.

Don't forget that for each picture, achieving the final result can involve drawing lots of lines that go wrong at first. Your pencil sketch can end up looking extremely messy, with lots of mistakes and alterations. But eventually, a decent drawing will emerge and you can erase all the other lines.

If you want it to look really clean before you add color, you could take a fresh sheet of paper, place it over your sketch, and put both sheets up against a windowpane so that the light helps you trace a copy of the final lines of your drawing. Then use one of the methods covered in this book to add some color.

Ready?

Biker Girl

This is biker girl Revvy. You'll see from the sketch I drew when I was working out her pose that I needed to sketch a lot of rough lines to achieve the final result.

Step 1

We are drawing Revvy from a ¾ viewpoint. She is leaning forward, so the head, chest, and hip shapes line up diagonally—the head slightly overlaps the chest. The hips should be relatively small since these are farthest away from us. The lines forming the neck and lower part of the spine curve away from us. Notice the angle of the collarbones—this lifts the shoulders to make the arms stand farther away from the body, creating an active pose. The leg bones cross each other near the top to create a wider stride. The back foot appears much smaller than the one that's raised up in front.

Step 2

Mark the outline shape of Revvy's flesh and muscle. Study this carefully to get the proportions right—she has muscular arms, a curvy chest, and a narrow waist.

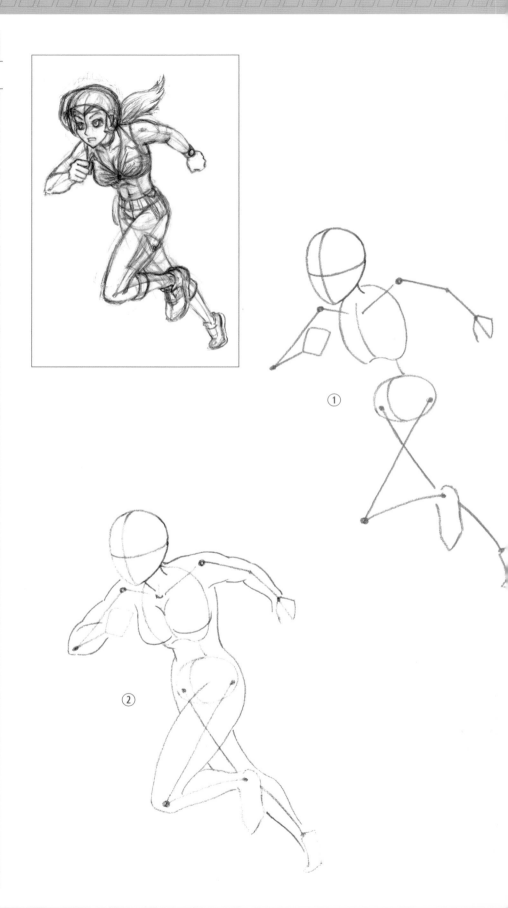

Step 3

Draw the basic outline of Revvy's helmet, sleeveless shirt, pants and running shoes—take a look at the finished picture on the next page to see these items more clearly. Next add the facial features—notice that the mouth is slightly open. Her ponytail flies up at the back to add to the sense of movement. Work on the hands—spend some time getting the shape of the knuckles and fingers on the front hand right so you capture the tightly clenched fist. Put a choker around the neck and mark the belly button.

Step 4

Draw a visor on Revvy's helmet. Put a collar on her shirt and add the belt and pockets to the pants. Copy all the crease lines on her clothes. Now for the shoes—don't forget that the back one is much smaller because of the perspective. Add some more detail to the hair and give her a wristwatch. Work on the facial features, making the long thin eyebrows sit high above the eyes.

Step 5

Go over the outlines with your fine felt-tip pen, adding extra detail and texture as you go, like the rough edges of the shirt's armholes that make it look like the sleeves have been ripped off. Add extra lines to the upper body to give more definition to the muscle, flesh, and bone. Turn the belly button into a cross shape.

>>

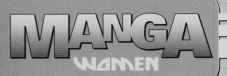

<< Step 6

Go over some of the lines of your drawing again to vary the weight of the line. Add some shading to the eyes, mouth, choker, watch strap, and belt. Leave the ink to dry, then erase all your pencil guidelines.

Step 7

I've colored my picture using a computer. Look back at the Color section of this book and follow the steps to do this. You'll start by adding the flat color.

Step 8

This is what Revvy looks like after I added some shadows.

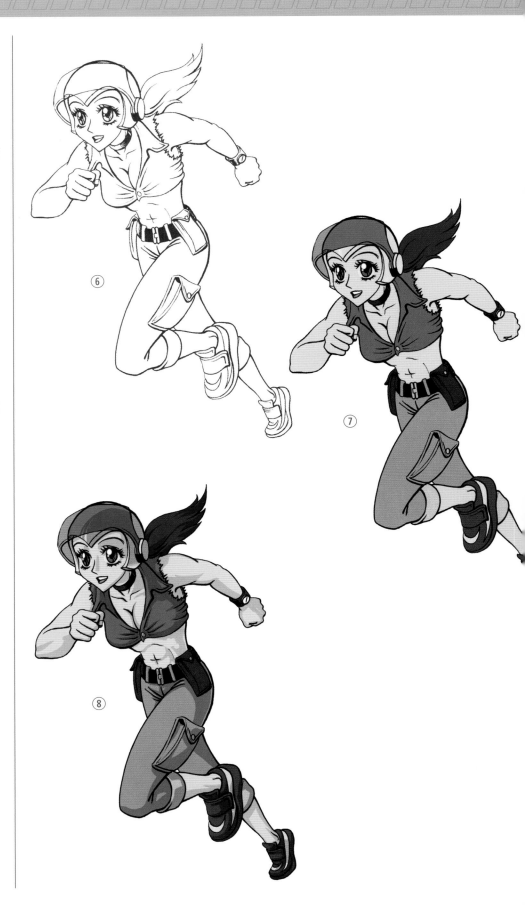

Step 9

Here I've added some highlights—notice the glint on the visor and the lighter patches on the hair. The other highlights are more subtle—different surfaces reflect light in different ways.

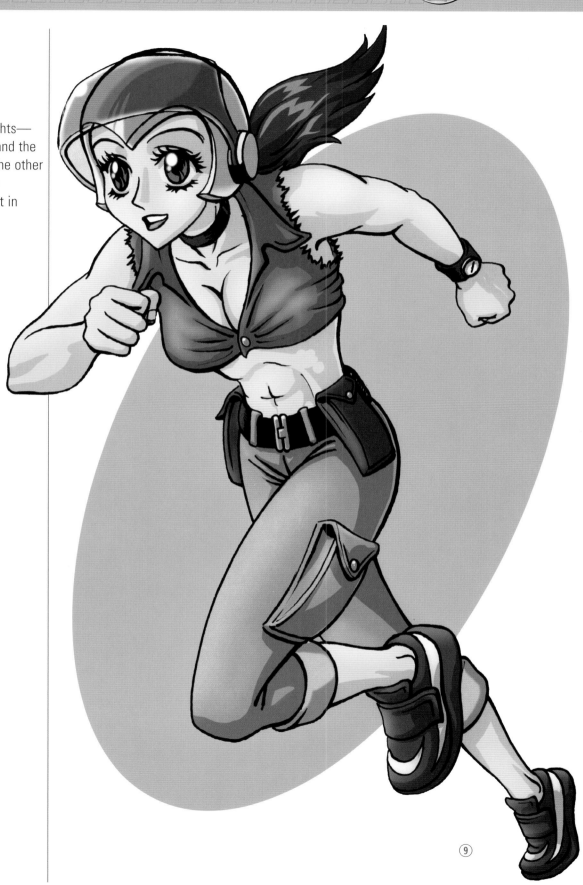

⑨

Warrior Queen

While you work through this final exercise, think about the character you're drawing. What's her name? Where's she from? Does she have special powers? Working out what you are trying to convey through your characters will make your drawings much more believable and interesting. As you can see from my original sketch, I changed my mind about this picture a few times before I decided on the final pose.

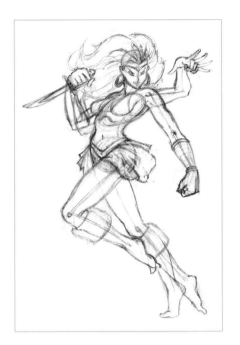

Step 1

Carefully copy the ovals for the three main body parts. Study the oval forming the chest—instead of being upright, it's almost lying on its side. This creates the extreme arch of the back. The hips are thrust forward while the head twists in a different direction and tilts down slightly. The joint at the top of the back leg sits partway across the hips to make this leg stretch farther back. Both feet are sharply angled so the warrior almost appears to be flying.

Step 2

Draw on the body outline. Overlap the curves on the outstretched arm to give the muscle more definition. Make the waist narrow to emphasize the broadness of the upper body.

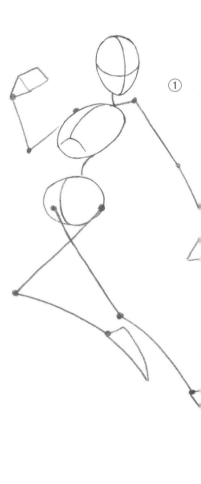

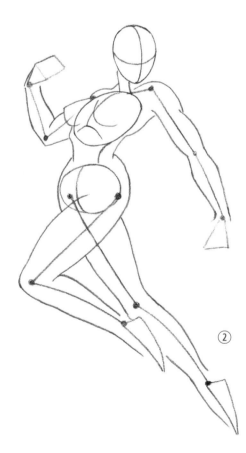

Step 3

Map in the basic shapes of the clothing and hair. Copy the shape of the skirt to capture the flimsy, floaty look. Work on the dagger and the hand holding it. Place the facial features, making the eyes small.

Step 4

Draw around the tops of the boots to show their shaggy texture. Add some guidelines to the hair and make the eyebrows extremely angular. Draw the irises and pupils low down in the sockets. Add two large loops for earrings.

Step 5

Once all your guidelines are in place, you can enjoy establishing the final drawing with a pen. Add a few more details as you go, like the curves on the armulets to help show they are metallic and the fold lines of the fabric at the back of the ankles.

>>

When you are creating your own character, try copying a friend's hairstyle and look in a catalogue for clothing ideas. Borrow bits from manga characters on TV too.

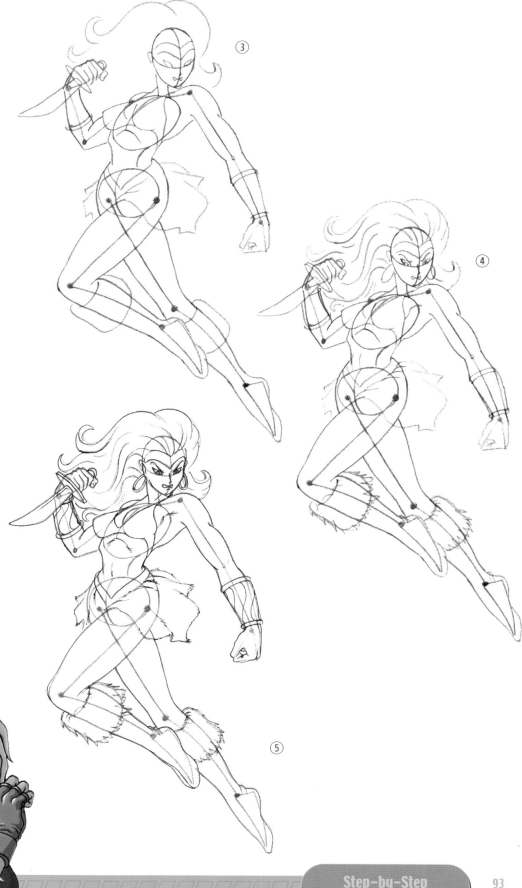

Step 6

Now vary the weight of the ink lines to accentuate the curves and lend the figure a sense of solidity. I've also added a thin strip of hair down either side of the face. Look carefully at the small lines I've sketched on the upper body here—this technique really accentuates the warrior's muscular shape. When you work on the leopard-skin pattern of the skirt, notice how the black shapes run into each other where the skirt folds.

Step 7

I colored my picture by computer—there is more information on this in the Color section of this book. You start by adding flat colors like I've done here.

Step 8

Next I added some shadows. I also made some parts of the picture, like the hair and the waistband of the skirt, a deeper shade.

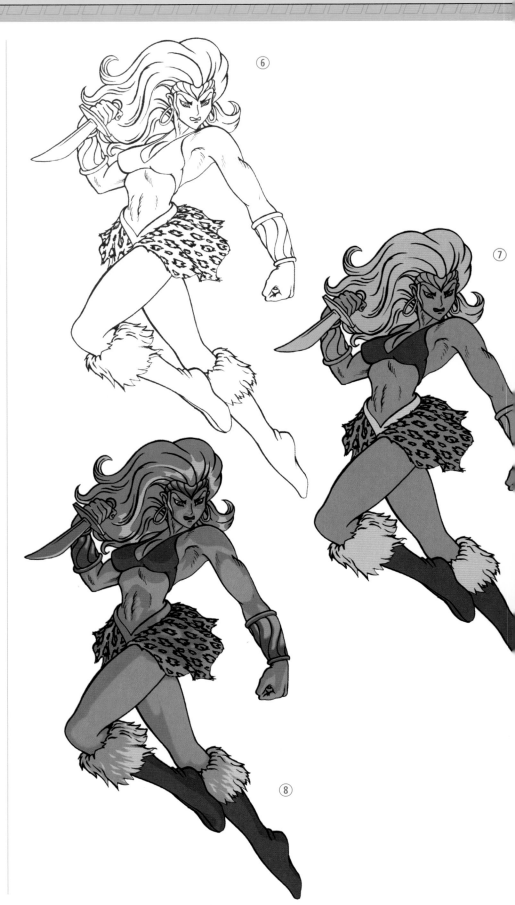

Step 9

Our warrior queen is at the peak of her power. Note the additional enhancements: the glinting steel of her dagger, the armulet and headband, and the burnished, smooth tones of her skin. Compare this picture with the previous one so you can see exactly how I've enhanced it.

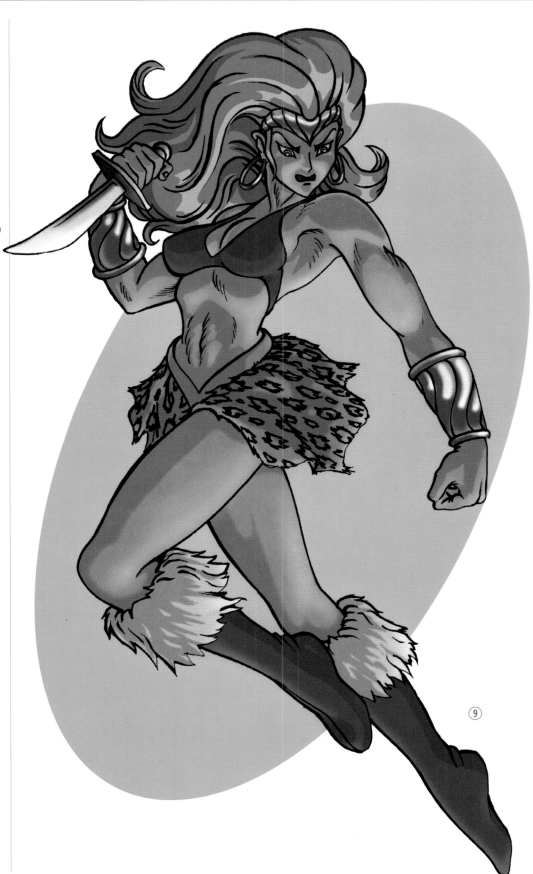

⑨

aving successfully negotiated your way through this book, you should have come across all the techniques you need to invent your own manga female characters—you should be able to draw them in all sorts of poses, from all angles, in whatever clothing you want to invent for them. Look back through the book whenever you want some ideas for faces, hairstyles, and clothing—mix and match the ideas.

Other books in this series will instruct you in drawing male characters, characters in action, robots, and animals, as well as in more advanced work like background scenes, and extreme perspective.

Any kind of drawing will increase your skills and help you to draw better manga artwork. Carry a sketchbook with you wherever you go so you can practice whenever you get a moment. Think about how you can turn people you see and meet into manga characters by exaggerating their characteristics and poses.

Remember that there will always be new things for you to learn about drawing. These will keep you entertained for a lifetime!